FLOOD

The Earth series traces the historical significance and cultural history of natural phenomena. Written by experts who are passionate about their subject, titles in the series bring together science, art, literature, mythology, religion and popular culture, exploring and explaining the planet we inhabit in new and exciting ways.

Series editor: Daniel Allen

Flood

John Withington

REAKTION BOOKS

Published by
Reaktion Books Ltd
33 Great Sutton Street
London EC1V 0DX, UK
www.reaktionbooks.co.uk

First published 2013

Copyright © John Withington 2013

Printed and bound in China by Toppan Printing Co. Ltd.

A catalogue record for this book is available from the British Library

ISBN 978 1 78023 196 9

CONTENTS

Foreword

Floods have many causes – rain, melting snow and ice, storms, tsunamis, tides, the failure of dams or dykes, acts of war. They afflict humanity more often than any other natural disaster. So it is not surprising that they have played such a prominent role in myth and religion, nor that they have inspired so many writers and artists. Some of humanity's biggest and most ingenious structures have been pressed into service to try to keep them at bay, but now, at the dawn of the third millennium, there are fears that floods are becoming more dangerous than ever before, and that the human race faces its toughest struggle yet with the waters.

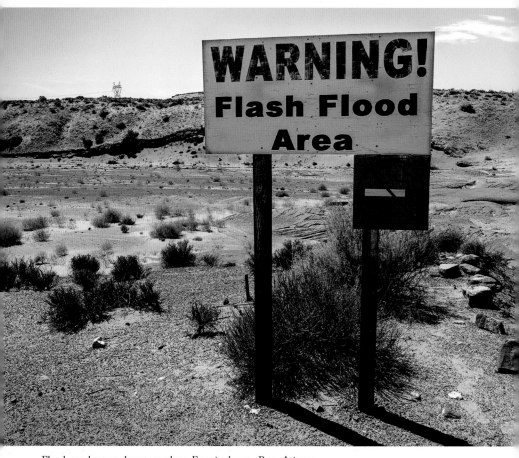

Floods can happen almost anywhere. Even in deserts. Page, Arizona.

1 Myth

In the beginning God created the world, but things soon started to go horribly wrong. Adam and Eve ate forbidden fruit, and were expelled from the Garden of Eden. Then one of their sons, Cain, killed his brother Abel. Indeed, by the time humanity had gone through ten generations, God was getting pretty desperate, as He saw that 'the wickedness of man was great in the earth, and that every imagination of the thoughts of his heart was only evil continually' (Genesis 6:5). In fact He began to wish He had never bothered creating human beings. Fortunately, there was one 'just' man named Noah, who 'walked with God' (6:9), so the Almighty told him to build a wooden ark about 550 feet (170 m) long, into which Noah was to take his wife, his sons and their wives, plus specimens 'of every living thing' (6:19). As for the rest of the world's inhabitants, God was going to make it rain for 40 days and 40 nights, with the resulting flood designed to kill 'every thing that is in the earth' (6:17). When the rain poured down, Noah's ark 'went upon the face of the waters' (7:18), but disaster soon overtook the rest of humanity: all the mountains were submerged and every living thing drowned. After a time, God 'restrained' the rain; the flood began to subside and eventually the ark came to rest on a mountain. Noah sent out a dove, which came back the first time, having 'found no rest for the sole of her foot' (8:9). The second time she returned carrying an olive leaf, which Noah took as a sign that the waters were going down. The third time, she did not return. Eventually God instructed Noah to take his family and his menagerie out of the ark. They wasted no time in building an

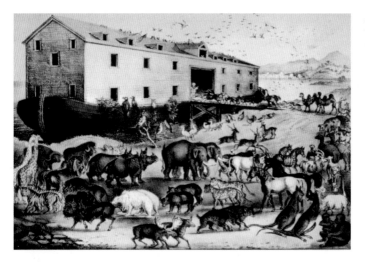

Noah's Ark, an American view, printed by Currier & Ives, 1856–1907.

altar, and making 'burnt offerings'. God 'smelled a sweet savour' (8:20–21), and promised never to flood the world again, setting a rainbow in the sky as a sign of His vow.

It is one of the most famous of all Bible stories, but is it one story, or two? In Genesis 6:19 God tells Noah to take just two specimens – 'male and female' – of every living thing, but just a few lines later in 7:2–3, the instruction is: 'Of every clean beast thou shalt take to thee by sevens, the male and his female: and of beasts that are not clean by two, the male and his female. Of fowls also of the air by sevens, the male and the female'. And what causes the flood? We generally assume that it was the 40 days of rain, but, according to Genesis, something else happened: 'all the fountains of the great deep' were 'broken up' (7:11). Is this meant to refer to some sudden, catastrophic rise in sea level? There is also confusion about how long the flood lasted. On one reading, Noah spends just 61 days in the ark, but other parts of the narrative suggest that it was a whole year. These apparent discrepancies led some scholars to believe the account was based on more than one source, with the accounts not amalgamated particularly skilfully.

Then during the nineteenth century came a dramatic discovery that would raise more profound questions about the origins of the story. In 1839 a young English lawyer named Austen Henry Layard began excavating the ancient city of Nineveh

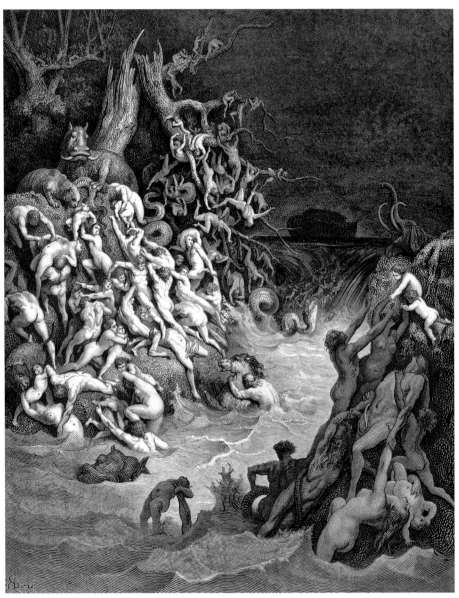

'And all flesh died that moved upon the earth.' Noah's flood as depicted in one of Gustave Doré's famous Bible illustrations from 1866.

in Mesopotamia (modern-day Iraq). Over the years, he and his collaborators would bring back thousands of broken clay tablets covered in strange wedge-shaped characters. Some told of another great deluge in a story called the Epic of Gilgamesh. Gilgamesh appears to have been a real person who ruled another Mesopotamian city, Uruk, around 2700 BC. In the epic we are told that he wanted to gain immortality, so he set off to find Utnapishtim, 'whom they call the Faraway', who was supposed to know the secret.[1] His quest entailed a long and perilous journey, with Gilgamesh penetrating mountains guarded by fearful creatures, half-man, half-dragon, where no explorer had ever before ventured, but the king conquered all the dangers and obstacles until at last he stood before Utnapishtim, and was able to ask for his secret. Utnapishtim replied that he too had been a king – of another ancient Iraqi city, Shuruppak, on the banks of the Euphrates, where 'the people multiplied, the world bellowed like a wild bull'. The noise got so bad that the gods were disturbed, and Enlil, god of storms, complained: 'The uproar of mankind is intolerable and sleep is no longer possible', so they held a council and decided 'to exterminate mankind', but Ea, the god of wisdom and one of the creators of humanity, was determined that at least one human should survive. So, in a dream, he told Utnapishtim to tear down his house, abandon his possessions and build a boat into which he could take 'the seed of all living creatures.' His family helped him build a vessel with seven decks. Shipwrights were also drafted in, and after seven days, it was finished. Utnapishtim took aboard his family, his gold, 'the beast of the field, both wild and tame, and all the craftsmen.'

At dawn the next day 'a black cloud came from the horizon', and Enlil 'turned daylight to darkness'. But before the rains came, 'the gods of the abyss rose up; Nergal pulled out the dams of the nether waters, Ninurta the war-lord threw down the dykes.' Then the tempest raged, pouring over people 'like the tides of battle' so that even the gods were terrified and 'crouched against the walls, cowering like curs'. For six days and six nights 'the winds blew, torrent and tempest and flood overwhelmed the world', until at dawn on the seventh, the storm subsided and the sea grew calm;

The Flood Tablet, relating part of the Epic of Gilgamesh, 7th century BC.

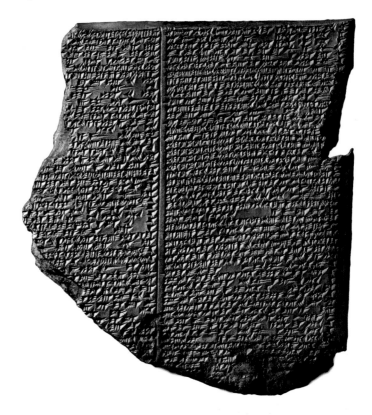

though by then, 'all mankind was turned to clay'. So, after a week, at the stage where Noah's downpour was still barely getting into its stride, Utnapishtim's boat was settling on a mountaintop. After sending out a dove, he made a sacrifice of cedar and myrtle, and the gods gathered to smell 'the sweet savour'.[2] Even Enlil blessed Utnapishtim and his wife, and he was taken away by the gods to live forever. At the end of this gripping tale, though, the Faraway had disappointing news for Gilgamesh. Immortality was not the king's lot. He was doomed to die.

The similarities between the stories are striking – the divine determination to destroy a world gone wrong, but to save a right-eous man, his family and examples of each animal; the flood; the boat that comes to rest on a mountain; the sending out of a dove; the sacrifice. The Gilgamesh story is one of the oldest in the world, and may have been compiled as early as the third millennium

BC, while the Book of Genesis reached its final form perhaps around the fifth century BC, though parts may have been much older. There were a number of versions of Gilgamesh's epic. A fragment, for example, was found in the ancient Palestinian city of Megiddo, so it is possible that the authors of the Bible may have been familiar with it. The British archaeologist Sir Leonard Woolley took the view that the story of Noah was clearly derived from the Gilgamesh tale, but the question that really fascinated him was whether the great flood was a real event or just a legend. By 1929 Woolley, the son of a clergyman, who was assisted by Lawrence of Arabia on some of his excavations, believed he had the answer to his puzzle, and published it in perhaps the most popular book ever written about archaeology, *Ur of the Chaldees*.

Digging at the ancient Mesopotamian city of that name, the home of Abraham, he had discovered an 8-foot (2.5-m) layer of clay containing no human remains, which he believed had been deposited by a flood that happened no later than 3200 BC. Could this inundation have prompted the ancient story? Woolley believed that the layer of clay marked 'a definite break in the continuity of the local culture; a whole civilisation which existed before it is lacking above it and seems to have been submerged by the waters'. That led him to conclude that this event was indeed 'the Flood on which is based the story of Noah'. As Woolley himself conceded, floods were common in Mesopotamia, but he maintained that this one 'must have been of a magnitude un-paralleled in local history'. He did not, however, claim that it was the worldwide cataclysm of the stories of Utnapishtim and Noah, saying that it was 'confined to the lower valley of the Tigris and Euphrates, affecting an area perhaps 400 miles long and 100 miles across; but for the occupants of the valley that was the whole world!'[3] Later excavations in the area failed to find a similar level of silt, though, and it began to look as though Woolley's flood must have been confined to just a few square miles, meaning that it was no more significant than many others involving the two rivers. If a truly catastrophic flood was at the root of the stories of Gilgamesh and Noah, surely this was not it.

The Bosphorus,
Istanbul, *c.* 1890–1900.

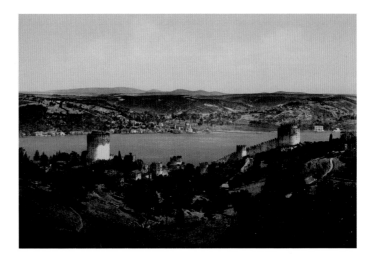

Nearly 70 years later, in 1997, a dramatic new candidate for the great flood of Noah and Gilgamesh was advanced by two marine geologists from Columbia University in the United States. William Ryan and Walter Pitman suggested that there had indeed been a great flood, about 5,000 years before Christ, but that it had not happened in the Middle East. Using evidence from their own explorations, along with data collected by other scientists, they said that until the sixth millennium BC, the Black Sea was an inland freshwater lake much smaller than the one we see today, lying up to 500 feet (150 m) below the level of the Mediterranean, which was held back by a natural dam where we now find the Bosphorus Strait. The world's oceans had been rising relentlessly since the last great Ice Age ended about 11,700 years ago, and under this pressure the natural barrier holding back the Mediterranean eventually started to give way. At first the water came over the top quite gently in streams, but then the dam broke, and in a few days it became a torrent, dashing down at 200 times the power of Niagara, tearing up trees and sweeping along boulders, making it formidable enough to cut a channel through solid rock. For 300 days it was a violent cascade until gradually it slowed down again, though it kept rising until the Black Sea was at the same level as the Mediterranean. The theory appeared to be confirmed by samples from the bed of the Black Sea suggesting

that what had once been dry land around it had been drowned by salt water, while carbon-dating of shellfish remains pointed to the arrival of new saltwater species about 7,500 years ago. Ryan and Pitman believe that by the time the flood came, the shores of the Black Sea would already have been home to farmers and artisans, and this deluge would indeed have seemed truly apocalyptic to anyone unlucky enough to be caught up in it. Those fortunate enough to have survived would have taken traumatic memories of it with them as they sought refuge in new lands, such as Mesopotamia. Interestingly the ancient inhabitants of Samothrace in the Aegean Sea had their own tradition of a great flood in the Black Sea region, one in which the sea was said to have risen and covered a large part of their island, forcing the survivors to retreat to the highest mountains. Their version too turned on the bursting of a natural dam that separated the Mediterranean from the Black Sea, but they believed the water had rushed into the Mediterranean rather than out of it.

And in modern times Ryan and Pitman's hypothesis has not had things all its own way either. Scepticism was voiced by Russian and Ukrainian scientists who had built up a formidable body of archaeological, environmental and geological evidence about the Black Sea. Some of them maintain that there would not have been any farmers to flee a deluge and tell the tale, as agriculture did not flourish in the area until 1,000 years after the flood is supposed to have happened, and that examination of microscopic marine shells suggested that the Black Sea basin had experienced a series of smaller inundations rather than one major deluge. Another hypothesis proposes that there was a deluge into the Black Sea, but that it happened perhaps 9,000 years earlier than suggested by the Ryan-Pitman theory and came from the overflowing of the Caspian Sea. Other scientists think that Mesopotamia itself experienced frequent monsoons and rising sea levels between 9000 and 8000 BC, which would have driven some people from their homes and might have provided the stimulus for an apocalyptic flood myth.

It may be hard to find a clear answer to the question of whether the story of Noah is inspired by a real flood – and, if so, which

one – but we do know that similar tales of a great deluge can be found all over the world. Greek mythology, for example, has Deucalion, whose story dates back to at least the fifth century BC. One of the best-known versions is a retelling by the Roman poet Ovid in his *Metamorphoses*, written around the time of Christ's birth. Again the story begins with a golden age, in which, even though there was no law to compel them, every human being 'kept faith and did the right', and just as in the Garden of Eden, the earth yielded up its fruits without man having to toil. After that, it was all downhill. The Silver Age was not so good, but at least it was better than the Bronze Age that followed, and then came the Age of Iron, when 'all evil burst forth . . . modesty and truth and faith fled the earth, and in their place came tricks and plots and snares, violence and cursed love of gain'. This reached the ears of Jove, the king of the gods, up on Olympus. He hoped it was not true, but came down to earth in human form to find out, and discovered that in reality things were even worse than he had been led to believe. So he 'shook thrice and again his awful locks' and declared: 'I must destroy the race of man.' He sent drenching rain, which beat down the crops, and called on Neptune to 'open wide' all his rivers, removing any obstacles in their way. The waters surged over waving grain, budding groves, houses, temples, sheep and men until 'the sea and land have no distinction. All is sea, but a sea without a shore.' Dolphins swam among the trees; wild boars, wolves, lions and tigers tried to float on the waters. Those few humans who managed to escape to the tops of high mountains were eventually overcome by starvation. In the end only the summit of Mount Parnassus pierced the flood, and it was there that 'a little skiff' arrived bearing Deucalion, the king of Phthia, and his wife Pyrrha: 'There was no better man than he, none more scrupulous of right, nor than she was any woman more reverent of the gods.'[4]

Deucalion had been warned about Jove's plan by his father, Prometheus, who famously stole fire from heaven. Prometheus told him to build a boat, although he received no instructions about saving animals, unlike Noah and Utnapishtim. Now when Jove saw these two lone, righteous survivors, 'he rent the clouds

asunder' and stilled the storm, while Neptune calmed the waves. Hills began to reappear, then the tops of trees and finally the ground beneath them. At first Deucalion wept to see that the flood had spared only his wife and him, but then they decided to go and ask the goddess Themis, who could see the future, by what means their race might be restored. Pyrrha was horrified when the goddess told her to go off and 'throw behind you as you go the bones of your great mother'. How could she desecrate her mother's remains in this way? But the king clarified Themis' remarks: 'our great mother is the earth, and I think the bones which the goddess speaks of are the stones in the earth's body.' Actually, neither was completely sure this was what the goddess meant, but asked themselves: 'What harm will it do to try?'[5] And indeed, the stones that Deucalion threw over his shoulder became men, while those cast by Pyrrha took the shape of women. After

Deucalion and Pyrrha throw stones over their shoulders to create humanity.

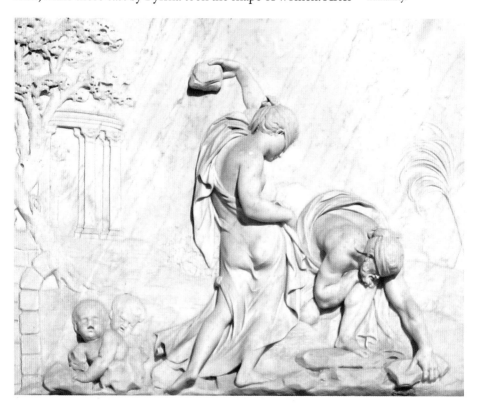

that, animals began to form, some of them previously unknown. Incidentally many learned ancient Greeks, including Plato, believed that Deucalion's flood was just one of a series of major deluges. His legend shares a number of crucial elements with the stories of Noah and Gilgamesh – the wrathful god or gods, the flood that consumes almost everything, the one good family that is spared – and a Hindu flood tale perhaps written around 700 BC follows a similar format.

In this story Manu, the first man, was washing when a fish came into his hands. It promised Manu that if he looked after it, it would one day save him. 'From what?' asked Manu. The fish, which was actually an incarnation of the god Vishnu, replied that a great flood was going to destroy the world. It added that, because the fish was in constant danger of being eaten by bigger fish, Manu must keep it first in a jar; then, when it got too big for that, he must dig a pit; and when it outgrew that too, Manu must take it to the sea. It soon became the biggest of all fish. It told Manu that the deluge was about to begin and ordered him to build a ship. Sure enough, the waters rose, and Manu got into the vessel. The fish 'swam up to him, and to its horn he tied the rope of the ship'.[6] It then towed Manu to the safety of a mountain. He had survived, but no other living thing was left alive. So, 'being desirous of offspring',[7] Manu offered up a sacrifice of clarified butter, sour milk, curds and whey. A woman 'was produced in a year' and the couple became ancestors of the human race.

As well as the famous flood myths of the Middle East, Greece and India, they are found in Southeast Asian countries such as Burma, Vietnam, Malaya and Indonesia; in New Guinea and Australia; in many South Pacific Islands, the Philippines, Taiwan, the Kamchatka peninsula of Far Eastern Russia, Lithuania, Transylvania and all over North and South America. The nineteenth-century painter of Native Americans George Catlin said every one of the 120 tribes he had visited across the American continents had a legend of a devastating flood that only a handful of people had survived. It seems unlikely that such widespread stories could all have originated from a single source, and more plausible that their prevalence is a reflection of the fact that floods

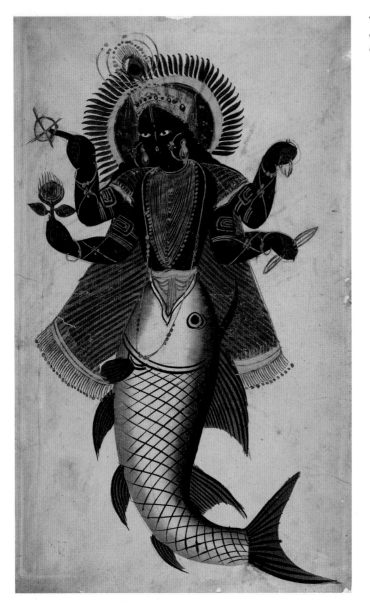

The incarnation
of Vishnu as a fish,
c. 1860.

One of many
pictures of Native
Americans painted
by George Catlin.
*Ball-play of the
Choctaw – Ball Up*,
1846–50.

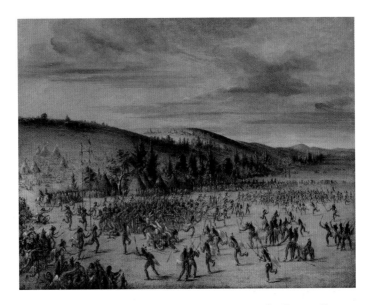

are the most common disasters known to man. Sir James George Frazer, considered by many to be the father of modern anthropology, made a study of flood myths and concluded that

> the similarities which undoubtedly exist between many of these legends are due partly to direct transmission from one people to another, and partly to similar, but quite independent, experiences either of great floods or of phenomena which suggested the occurrence of great floods, in many different parts of the world.[8]

There may be many myths, but there are a number of features which appear in most of them. The first is that the flood is not an accident but a conscious act, usually – though not always – performed by a god or gods. Sometimes, as in the stories of Noah and Deucalion, it is the general wickedness of mankind that angers the deities. In a Maori legend, for example, they send down two prophets to warn humanity of the error of its ways, but when these are ignored they follow up with devastating rains. In other stories, though, the deluge is retribution for some more specific act. The French Polynesian island of Raiatea has a tale of a flood sent

by the sea-god Ruahatu, who flies into a rage when fishermen get their hooks tangled in his hair while he is trying to take a nap. In places as far apart as Transylvania and New Guinea there are legends that hang upon man's inability to resist forbidden fruit, or rather fish. In the New Guinea story the people catch a magnificent fish, but a good man warns them not to eat it. They consume it anyway, and are all drowned by water bursting from the ground, apart from the good man and his family. The Transylvania legend begins with a Garden of Eden-style golden age, with meat growing on trees and rivers flowing with milk and wine. One day an old man appears at a cottage and asks to stay the night there. He gives the couple who live there a fish, but asks them not to eat it, saying that in nine days' time, he will return and that when they give him back the fish, he will reward them. But the woman becomes tormented by the thought that this must be a very special fish if the old man sets such store by it. Her husband tries to stop her but eventually she throws it on the fire to roast it. At once a flash of lightning strikes the woman dead; then it begins to rain. The old man returns as promised and tells the widowed man to build a boat and gather together his kinfolk, animals and seeds. It rains for a year, and they are the only survivors of the resulting flood, but in the new world they have to work for their food, and sickness and death appear for the first time.

In these stories the flood is retribution, but in others humankind is less culpable. In a story told by the Pima tribe of Arizona, as in the Gilgamesh legend, overpopulation is one of the things that sparks the gods' alarm, while in others, such as a myth from the Great Plains of central North America, humans are innocent victims of power struggles between gods. The Sioux related that the Sky-spirit created human beings and put them on the fertile earth, but Unktehi, the horned water-spirit of the Missouri River, took them for lice and she and her followers spouted water from their horns to flood the land and drown them. Only a few managed to escape by scrambling to the top of a mountain. They prayed for survival and the Great Thunderbird, Wakan Tanka, grandson of the Sky-spirit, along with his followers, set out to save them. For many ages they fought Unktehi and her

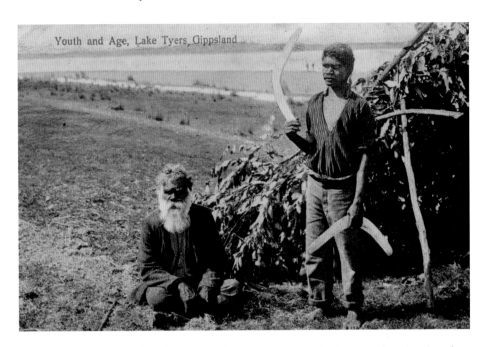

Youth and Age, Lake Tyers, Gippsland

Two Australian Aboriginal men near Lake Tyers, early 20th century.

offspring until at last they prevailed. Forever after the thunder-birds have tried to help humans, and humans have responded by honouring them. In a Fijian legend the deluge comes because two grandsons of the great god Ndengei kill the monstrous bird that wakes him every morning with its cooing, and he flies into a fury when he oversleeps. Other stories are equally picturesque. The Bahnar people of Vietnam tell of a kite that pecked a hole in a crab's skull during a quarrel. In his fury the crab caused the sea and rivers to swell so much that everyone was drowned apart from a brother and sister. According to Aborigines living near Lake Tyers in Victoria, all the water in the world was swallowed by a huge frog, to the despair of all the animals who got together to decide what to do to get it to disgorge, and came up with the idea of making the frog laugh. They tried everything they could, but the frog sat stony-faced until the eel stood on its tail and went into the most extraordinary contortions. The frog burst out laughing, but so much water poured out of its mouth that every human being was drowned, except for a few the pelican picked up in his boat.

So there are many versions of the 'why?' in flood legends, and the same is true of the 'how?' As we saw, it is not just rain that causes the floods of Noah and Gilgamesh. In each case there seems to be some sort of breaking out of water from the depths of the oceans. In many other myths, like that of the forbidden fish in New Guinea, the cause is not rain at all, and both the Taiwanese and the Inuit of Alaska have legends of floods brought by earthquakes, while the rising of the ocean is the reason for the catastrophe in stories from a number of islands, such as Tahiti and Hawaii, and with Native American tribes on the west coast of America. On the remote South Sea island of Mangaia rain plays its part, but it is abetted by a hurricane that generates enormous waves. For some Tinneh in North America the cause is a great fall of snow, while for Native Americans in Washington State the floodwaters were the unstoppable tears of a beaver who had been deserted by his human wife.

All the deluge myths have the common factor that they leave few survivors. Utnapishtim enjoyed special protection from one of the gods. Noah was saved for his virtue, rather like the good man of Transylvania who tries to stop his wife eating the special fish. In a similar legend from the Palau Islands of Polynesia, a group of gods come down to earth disguised as beggars. When they ask for food and lodging people turn them away, except for one old woman who receives them kindly. She is the only one spared from the flood. For a female to be the sole survivor is unusual. In most of the myths the principal character tends to be a man, though the natives of Enggano, an island to the west of Sumatra, also tell of a woman being the only person left because her long hair caught in a thorny tree and she was able to cling on for dear life. In Sulawesi the Toraja have only a pregnant woman left after the deluge. A pregnant mouse, which also survives, helps her to find food, but in return extracts the promise that mice will for ever after have the right to consume part of humanity's harvest. Non-humans also play important roles in other stories. The only survivors in the flood myth of the Atá tribe in the Philippines get away on the back of a great eagle. For the Chiriguanos of Bolivia the only people left are two

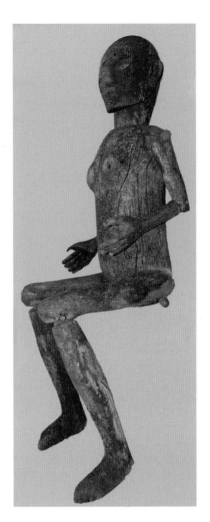

Wooden effigy of a female figure, made by the Toraja in Sulawesi.

babies who float off on a maté leaf, and are then helped by a toad, while the sole survivor in the mythology of the Ashochimi of California is a coyote who collects feathers from all manner of birds and plants them in the ground. In time they grow into men and women.

As with Noah, Utnapishtim and Deucalion, the favoured means of escape is usually a boat of some kind. The Huichol tribe in Mexico have a story of a young man who was trying to clear a field to plant crops, but found every morning that the trees he had cut down the day before were back as tall as ever. On the fifth day he met an old woman who told him that she was the

one who restored the trees each night. Angrily he asked her why, and she said it was because she needed to talk to him. He was wasting his time cutting down the trees, because in five days there was going to be a great flood. Though the young man did not realize it, the woman was actually Great-grandmother Nakawe, the goddess of earth. Not only did she tell him to make a wooden box and get inside, she even put on the cover and made it water-tight, enabling him to survive as the waters rose. When the pious and wise chief Marerewana of the Arawaks of Guyana was warned of a deluge, he chose to make a canoe, but rather than letting it be carried hither and thither on the ocean, he tied it to a tree so that when the waters subsided he would not be far from home. Others, though, found more exotic means of escape. Some fortunate Lithuanians sheltering on top of a mountain, on the point of being drowned by the great flood unleashed by the supreme god Pramzimas, spotted a huge nutshell he had discarded from his window while taking a snack and leapt into it, while the flood legend of the Cañari tribe of Ecuador features a magic mountain. Two brothers, the last of humanity, who were sheltering there, were relieved to see that as the waters rose, so did the mountain-top, and the means of escape for the final human pair in the legend of the Bataks of Sumatra is a clod of earth. In their story, as mankind was nearing extinction, the creator repented. He took the clod, tied it to a thread and laid it on the waters. The survivors stepped on to it, and it kept growing until it became the earth we inhabit today.

Repopulation of the world is generally the final episode in these legends of catastrophic floods. Sometimes this is less than straightforward. At the end of the Taiwanese deluge caused by an earthquake, just a brother and sister survived. As the only remaining human beings, they thought they had better marry each other, but felt a 'natural delicacy' about it.[9] So the man asked the sun whether he could marry his sister, and the sun said that it would be all right. But their union produced only a stone, and the moon told them this was because marriage between brother and sister was forbidden. Then, when the man died, four children burst from the stone and became the ancestors of the human race. In

A group of colourfully dressed Cañari, near Ingapirca, Ecuador.

a myth of the Macusis of Guyana the survivors adopt a similar solution to Deucalion and his wife, recreating mankind by throwing stones behind them. Then there are the tales where a mate appears unexpectedly. The Tinneh from Alaska told a story of a rich youth who makes a long journey by canoe with four of his nephews to woo a beautiful maiden who has rejected many suitors. He proves no more successful, and sadly decides to return home. As they push off from the shore, a woman appears and offers the man her baby girl, saying that he should take her if he wants someone beautiful. The man accepts the child and as they paddle off, the woman who has rejected his suit comes down to the edge of the water and begins to sink into the soft mud. She cries for help, but the man says it is her own fault, and she is swallowed up. Her mother is furious and orders a group of bears to raise huge waves and drown the rejected suitor. They dig up the bottom of the lake so ferociously that not only are the four nephews drowned, but the rest of humanity as well. Only the

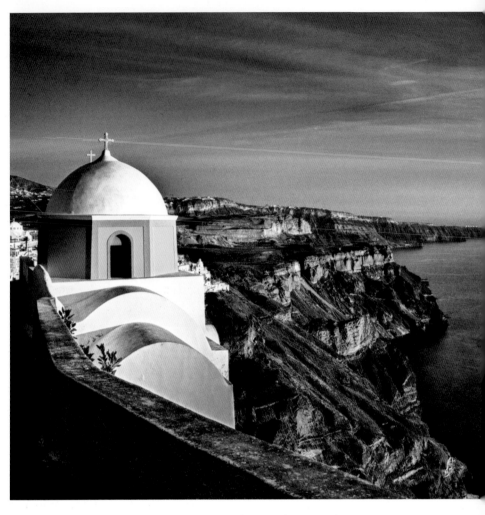

young man escapes, and as his canoes speeds over the waves he looks behind him and sees that the baby has turned into a beautiful woman. He marries her, and their offspring repopulate the world. The two Cañari brothers from Ecuador sheltering on their magic mountain were kept alive, after the waters subsided, by two macaws with the faces of women who provided them with food. They took the smaller one as a wife (the bigger one flew off), and by her they had six sons and daughters from whom all Cañari are descended. The Huichol saved by Nakawe was told

Santorini today. A clifftop church in Fira.

to take a canine companion with him. The man and the bitch lived together in a cave while he carried on clearing the field he had been working on before the floods struck. Every night he would come home to find that cakes had been baked for him. After five days he decided to stay behind and hide to find out who was making them. To his astonishment, he saw the bitch strip off her skin to reveal a woman beneath. At first she was very upset at the discovery of her secret, but eventually she became reconciled to her new status, and the couple went on to have a big family.

Not all flood myths, though, are on the apocalyptic scale. There are also stories involving the loss of just part of the world – the most famous being that of Atlantis. Plato wrote about a rich island to the west of the Strait of Gibraltar that was supposed to be bigger than Asia Minor and Libya combined and to have conquered many of the lands bordering the Mediterranean. Eventually its people became corrupt and their island was sunk by an earthquake. Nowadays it is generally assumed that the story of Atlantis is no more than a legend, though some believe that it may have originated from the violent volcanic eruption that blew apart the Greek island of Santorini and unleashed a fearful tsunami on Crete about 1,500 years before Christ.

The Welsh have a story of a lost kingdom called Cantre'r Gwaelod in Cardigan Bay, which boasted sixteen fine cities. The realm was protected by a series of embankments that were the responsibility of a man named Seithennin, but during a night of feasting he passed out in a drunken stupor and forgot to close the sluices. Cantre'r Gwaelod was flooded and disappeared. It is said that a ridge of rock and pebbles called Sarn Badrig, or St Patrick's Causeway, which can be seen at low tide to the north of Barmouth, is a relic of one of the flood defences, and that on quiet evenings the church bells of the lost cities can still be heard tolling beneath the waves. The fact that stumps of trees are visible at low tide on beaches in Cardigan Bay, such as Borth, has led to speculation that there might be some factual basis to the legend, but there is no reliable evidence of any substantial community having disappeared beneath the waves.

Just across the Channel in Brittany, they have another legend of a land lost in a flood. It is said that the city of Ys in what is now the Bay of Douarnenez was also protected from the sea by a great dyke. Its ruler was a pious and saintly king named Gradlon who had a beautiful but lascivious daughter, Dahut. In the dyke there were huge sluice gates, the key to which was kept by Gradlon, but one night his daughter stole it and, in a state of drunken abandon with one of her lovers, opened the gates. As the waters rushed in Gradlon tried to flee on his steed Morvarc'h, grabbing his daughter and lifting her up behind him. With the tide lapping at his horse's hooves, the king heard a voice telling him to throw the 'demon' into the sea, or he would surely die.[10] The moment he let his daughter fall, the waters receded enough for him to escape to Quimper, but Ys was lost forever, while Dahut lived on as a mermaid luring sailors to their doom.

There may be no obvious basis in fact for these Celtic flood legends, but some from other parts of the world seem to have been inspired by, or designed to explain, a peculiar feature of a landscape. A deep cleft in the Thessalonian mountains is said to have been produced by Deucalion's flood. It is a similar story with the Tequendama waterfall in Colombia. The Muisca people from that country said that long ago they offended a second-rank god,

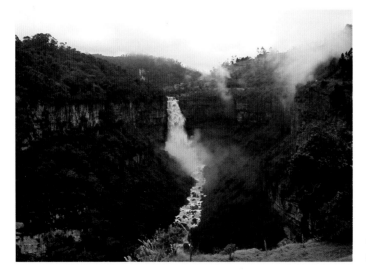

Tequendama Falls, Colombia.

Submerged forest exposed at low tide on Borth sands near Ynyslas, Ceredigion, Wales.

who sent such fierce torrents of water that they were no longer able to grow their crops, so they prayed to the great god Bohica. He threw his golden wand and split the mountains from top to bottom at the point where the waterfall is now found, emptying the water from their land. Half an ocean away, the remote island of Mangaia in the South Pacific is surrounded by natural coral cliffs facing the sea. Behind it are low hills punctuated by streams which rise to a plateau in the centre. According to native legend, it used to have a gentle uniform slope to the sea. Then Aokeu, the lord of rain, began a competition with Ake, whose job was to tread down the floor of the ocean, to see who could perform the most impressive feat. To try to gain an advantage, Ake called on Raka, the god of the winds, who blew up a fearful hurricane, while

two sons of the storm god generated 100-foot waves. In retaliation Aokeu called on his favourite element, the rain, and caused it to fall in sheets for five days and nights. The flood generated by the wind and rain scoured out deep valleys on the island until it began to assume its present shape.

2 Reality

Like those in myths, real floods come in many shapes and sizes – heavy rain, melting snow, tidal surges, storms, tsunamis, dyke and dam bursts, mudslides and even acts of war. They claim their first victims as people are drowned or struck by floating debris, but often kill greater numbers later through exposure, starvation and disease. Among the earliest floods we know of that occurred close to the United Kingdom is a storm surge in the North Sea that struck the Netherlands in AD 838. A chronicler writes of a great wind whipping the sea into a sudden and terrifying flood that destroyed buildings and drowned nearly 2,500 people. Two and a half centuries later, on 11 November 1099, the *Anglo-Saxon Chronicle* recorded that the sea 'rushed up so strongly and did so much damage that no one remembered anything like it before'.[1] In 1176 the Dutch suffered again as the waters broke through dykes into low-lying land, drowning a 'multitude of men'. A century later, in December 1287, a flood struck the Zuiderzee region as well as the village of Hickling in Norfolk, where, according to a contemporary chronicler, it

> suffocated or drowned men and women sleeping in their beds with infants in their cradles ... Many, when surrounded by the waters, sought a place of refuge by mounting into trees, but benumbed by the cold, they were overtaken by the water and fell into it and were drowned.[2]

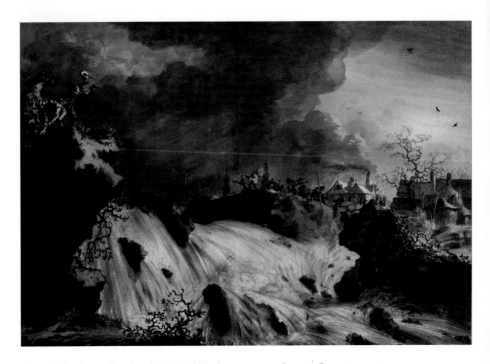

One of the worst floods of the Middle Ages occurred on 15 January 1362. It began with a great storm that made its devastating way across the British Isles, tearing roofs off houses in Dublin and flinging thousands of trees to the ground in southern England. Church towers at Bury St Edmunds and Norwich were flattened, and as the storm reached the North Sea it combined with a high tide to create a fearsome surge, drowning forever the port of Ravenser Odd at the mouth of the Humber. Next it hit the coasts of the Netherlands, Germany and Denmark. The wealthy city of Rungholt on the island of Strand off the coast of Denmark met the same fate as Ravenser Odd. Across the diocese of Schleswig, where Rungholt lay, a contemporary chronicler reported that 60 parishes were swallowed up by the sea. At the time it was said that what became known as the Grote Mandrenke – the Great Drowning of Men – had cost 100,000 lives, though most modern estimates put the figure at 25,000 or fewer. Over the next two centuries the region suffered a number of major floods, and during the night of 1 November 1570 the sea struck

A 17th-century Dutch flood. Willem Schellinks, c. 1651.

again. The All Saints' Flood began by drowning people in coastal areas while they slept. Then the waters inundated Amsterdam, Rotterdam and Dordrecht, making some of those who saw them believe that this was a repeat of Noah's flood. In a letter written shortly after, the royal treasurer for South Holland, Andries van der Goes, stated that 'the sufferings and the damages are so immense that words cannot describe them.'[3] Estimates of the number of dead again ran to 100,000, but according to some modern calculations the true figure may be more like 4,000. These casualty figures from ancient floods often appear to be greatly exaggerated, but there is no doubt that the lands bordering the North Sea suffered dreadfully, with one climatologist calculating that between 1099 and 1570 nearly 300 towns and villages were destroyed.

Less than 40 years later, on 30 January 1607, Britain was struck by its deadliest ever flood, and perhaps its worst ever natural disaster. A contemporary pamphlet, *God's Warning to His People of England*, reported:

> There happened such an overflowing of waters, such a violent swelling of the seas and such forcible breaches made into the firm-land . . . the like never in the memory of man, hath ever been seen or heard of.[4]

The pamphlet maintains that the terrible event came literally out of a clear blue sky, though other accounts from the time refer to the weather being stormy. About nine o'clock in the morning, says *God's Warning*, 'the sun being most fairly and brightly spread', people in Somerset, Gloucestershire and South Wales were going about their business. But those who looked up for a moment saw in the distance 'huge and mighty hills of water, tumbling one over another' and approaching very fast. Some were dazzled by the sight because it appeared that these mountains of water were topped by flames, as though 'millions of thousands of arrows' were all on fire; the arrows seemed to be hurtling towards them 'with such a smoke' and faster than the birds could fly. Many who witnessed the dreadful spectacle fled for their lives, 'leaving

all their goods and substance, to the merciless waters', but the waves were 'so violent and swift' that within five hours, most of the area was flooded, and 'many hundreds of people both men, women and children were then quite devoured by these out - rageous waters'. Thousands of sheep, cows, horses, oxen, pigs and other creatures, both wild and domesticated, also perished, and houses were destroyed along with crops and hay, so that 'many men that were rich in the morning when they rose out of their beds, were made poor before noon the same day.' In the stricken counties on either side of the Severn and along the coast of South Wales those caught up in the flood had to take refuge on the tops of trees or churches for days on end, sometimes watching helplessly as their loved ones perished below. Some escaped by clinging to planks of wood or dead animals. A child of five was said to have been saved because his coat 'lay spread upon the tops of the waters'. It is estimated now that the waters covered an area of 200 square miles (520 square km), and that around 2,000 people died. Some scientists believe that the flood was caused by a tsunami, though others think it was a storm surge. For the writer of *God's Warning*, the experience had been a 'fearful punishment' for mankind; it averred that if the Almighty had not shown Noah the sign of the rainbow as a promise that He would never again flood the world, people might have believed this was the 'second deluge'.[5]

The Yellow River in China has flooded an estimated 1,500 times over the last 3,000 years. No wonder they call it 'China's Sorrow'. It is the muddiest river in the world and takes its name from the colour of the silt that constantly raises its bed and often blocks its flow. For centuries the authorities had built dykes to try to contain it, but the year of 1887 saw heavy rains, and the river began rising. The state of the embankments near the city of Chengchow left a lot to be desired, but the official in charge of their maintenance had refused to take action to strengthen them, saying the timing was inauspicious. Then on September 28, at a sharp bend in the river, the dyke gave way. What began as a gap of a few feet had soon expanded to 100 yards (90 m), and then half a mile, leaving the Yellow River free to surge across

the North China plain. It took a long time for word to reach the outside world, but finally, in January 1888, a report appeared in *The Times* that had been written by its correspondent two months previously. In it he described how the flood was 'spreading death and desolation to an unparalleled extent'.[6] Houses were covered in silt and at least 1,500 communities were swept away until an area the size of Wales was said to have been flooded. The total number of deaths from the flood itself and the famine and disease that followed was estimated at between 900,000 and 2.5 million, and *The Times* reported that officials considered responsible for the failure of the dyke were put in the pillory.

That was bad enough, but less than half a century later the Yellow River caused the deadliest flood of all time, and perhaps the worst natural disaster in human history, when it and the Yangtze both burst their banks. Three years of drought ended in the summer of 1931 with unprecedented heavy rains, and by the end of July 150 miles (240 km) of land along the Yangtze had been inundated up to 20 miles (32 km) from the riverbank.[7] In many places, according to a *Times* correspondent, the country-side had become 'one stupendous sheet of water'. In village after village houses were flooded to the rooftops and the inhabitants had to take refuge in sampans and junks. Sometimes, wrote the reporter, 'Small spits of land, slightly higher than the rest, were peopled by two or three families and their livestock. There they remained, their last card played, until death brought release.' Reports kept coming in of 'whole districts being suddenly wiped

Memorial to the Yangtze River floods of 1954, Wuhan, Hubei province.

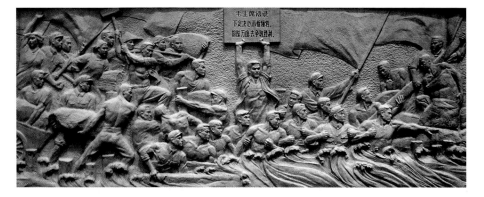

out by the bursting of a dyke, reports of 7,000 drowned here, 5,000 there'. The flooded lands were China's main rice-growing area. Now it was estimated that at best only 30 per cent of the summer crop could be saved, while in many areas there was no prospect of a winter crop. Lots of people had fled to the towns; 70,000 of them to Hankow, the 'great city' of the Yangtze. By September most of it was under 3 feet (90 cm) of water, and the price of food was soaring. Conditions were appalling:

Imagine a mud road about three miles long and 15 yards wide, with remains of mat sheds and bits of sacking serving as cover. People it with thousands of refugees of all ages and in all conditions of health. People it so thickly in your imagination that there is only a path four feet wide down the middle. Remember that about a quarter of them are children under the age of six. To this hell add pigs, chickens, ducks and emaciated dogs. Now realise that for this vast tightly-packed multitude, there are no sanitary arrangements whatsoever.[8]

The rains would continue until November, and the correspondent noted bleakly: 'If anyone dies there is nowhere to bury the body. Starvation and plague seem inevitable.' The city had been put under martial law, but every night there were dozens of robberies. At this time China was riven by civil war and disorder, and many of the dykes that had failed had been in a poor state of repair because of 'official lethargy and mismanagement'. While the country was wrestling with disaster, noted *The Times*, 'petty generals continue to struggle for the reins of government, and the loss of millions goes unheeded.'[9]

In the end more than 40,000 square miles (105,000 square km) were flooded, and perhaps 50 million people – a quarter of China's population – were driven from their homes. Refugees poured 'into empty schools and temples, filling every available space like the water that pursued them'. The authorities set up huge camps, and by April 1932 the ones at Hankow and Wuchang were packed with a total of more than half a million people.

A *Times* correspondent reported that they were accommodated in 100-foot-long (30-m) shelters, each of which held up to 80 families. In 'a pathetic attempt at privacy' many had created little wigwams from bamboo mats bent into a half-circle in which they would sleep and huddle together for warmth. Some families still had money and there were traders selling oranges, bean curd, fish and meat, but the free rice or grain the government had been distributing was now running out, and poorer people were already reduced to living on grass or the outer husks of rice. The correspondent was amazed by their 'passive acceptance of misery'. Medicines were in short supply, and smallpox, influenza and dysentery were running through the camps. The response of the authorities was mixed: 'shameful tales of misappropriation and peculation' co-existed with 'outstanding examples of what . . . energy and resource' could achieve. Charities and churches had pitched in. One mission ran a bath house for women, some of whom preferred to miss a meal rather than a bath: 'Food we may get another day,' they said, 'but not a bath.' The YWCA made an arrangement with a local Buddhist temple, and installed 250 women and children there, providing elementary schooling in the morning and sewing classes in the afternoon. 'From the hopeless misery of the camps,' wrote the correspondent, 'it was a relief to turn into the quiet busy cheerfulness of these temple courts.'[10] Sadly, though, these valiant efforts inevitably seemed 'insignificant in comparison with the misery of the whole', and with no one knowing where the grain for future crops was going to come from, he reported that the outlook could not be any worse. In the end it is estimated that 140,000 people died in the floods themselves and up to 3.6 million from hunger and disease in the aftermath. A report by the official flood relief organization calculated that crops worth $900 million had been lost, and put the total economic loss at $2 billion, a phenomenal figure for the time in what was still essentially a poor country. Even this figure, acknowledges the report, 'gives no indication of the complete dislocation of normal economic activities'.[11]

Another Yellow River flood in 1938 would carry off up to 800,000 people. This trio – 1887, 1931 and 1938 – are three of the

deadliest floods in the history of humanity, but the one in 1938 was not a natural disaster but an act of war. The Chinese Nationalist regime was faced with an invading Japanese army that was driving all before it, and which had on many occasions demonstrated how brutal it could be. For some time the Chinese had had a plan to halt the invader by breaching the Yellow River dykes. This was by no means the first time that flooding had been used as a weapon of war. In 1642, for example, the governor of Kaifeng had demolished dykes on the Yellow River to try to flood the camp of a rebel army, and had killed 300,000 people in the process. Deliberate flooding had also been used by the Aztecs against the Spaniards, and by the Dutch against the Spaniards and the French. Nor would it be the last: after the D-Day landings of 1944, for instance, German forces opened locks to flood the area behind Utah Beach in northern France. Many Allied paratroopers drowned as they landed, and the defenders were able to hamper the enemy advance from the beach and inflict heavy casualties.

In May 1938, as the Japanese captured city after city, the Chinese commander Chiang Kai-shek instructed that the Yellow River dykes at Huayuankou should be blown up. There are suggestions that the commander on the ground played for time, perhaps dreading the potential consequences, but on 11 May Japanese soldiers broke through into the area earmarked for flooding and he ordered the charges to be detonated. They ripped a 200-yard (180-m) gap in the dyke, and with a fearful roar the waters broke out. The tactic seemed to work. Japanese soldiers were drowned, tanks and guns were mired in mud and the progress of the invasion was slowed, by perhaps as much as three months. Yet the price was terrible. In addition to the hundreds of thousands killed, millions were driven from their homes as 4,000 villages were destroyed.

China also suffered the deadliest dam burst ever, in 1975, but those involved were no ordinary dams. During his Great Leap Forward, Chairman Mao ordered people all over the country to construct dams in order to provide great reservoirs. Unfortunately they usually had no knowledge of design and only the

most primitive tools. A senior official from the ministry of agriculture would later dismiss many of those built as 'completely worthless'.[12] In a few days during August 1975 fierce rainstorms dumped 3 feet (90 cm) of water on Henan province. On one day alone 17 inches (43 cm) fell. An eyewitness later recalled: 'The days were like nights as rain fell like arrows.' Early on 9 August the Shimantan dam on the Hong River burst, emptying more than 26 billion gallons of water into the valley below. Half an hour later the Banqiao dam on the Ru River went too, unleashing a wall of water 20 feet (6 m) high and 6 miles (9.5 km) wide. Survivors recounted: 'The blare of the dam burst sounded like the sky was collapsing and the earth was cracking. Houses and trees disappeared all in an instant.'[13] The first place in the flood's wake, the Commune of Daowencheng, was wiped off the map at the cost of nearly 10,000 lives. With the telephone system knocked out, no warnings were issued about the torrent, which was rushing along at 30 miles per hour (48 km/h). The city of Huaibin, which stood where the rivers meet, was washed away, and the deadly waters took another 60 dams with them until 4,000 square miles (10,400 square km) of farmland were flooded. Eventually the authorities admitted to 26,000 deaths, though they conceded that the number might be revised. According to some independent estimates, up to 230,000 people perished in the flood and from the famine and disease that followed. A hydrologist named Chen Xing had warned that the jerry-built dams were a disaster waiting to happen, and for his pains had been purged as a 'right wing opportunist'.[14] After the flood he was rehabilitated, but the failure of the dams was not discussed openly for 30 years. In 2005 Li Zechun, who had been a weather forecaster at the time of the flood and had since become an academician of the Chinese Academy of Engineering Sciences, declared that the 'tragedy was a man-made calamity rather than a natural one'.[15]

The death toll in the Boxing Day Tsunami of 2004 – the deadliest the world has ever seen – was also around 230,000. At one minute to eight on the morning of 26 December, under the sea about 100 miles (160 km) off the west coast of the Indonesian island of Sumatra, there was an earthquake with a force of 9.1,

the third biggest ever recorded. Nearly 1,000 miles of fault-line slipped around 50 feet (15 m), pushing up the sea bed and displacing 7 cubic miles (30 cubic km) of water. The first wave of the tsunami this generated would hit Sumatra within fifteen minutes, but over the next seven hours coastal areas across more than a dozen countries would be devastated. A warning system for tsunamis in the Pacific 'Ring of Fire', the most seismically active region on earth, had been established in 1948, but in 2004 there was none for the Indian Ocean, and most of the victims were taken completely by surprise. In many places the first sign of anything unusual was the spectacle – now familiar from television broadcasts – of the sea being mysteriously sucked away from the shore, leaving bemused swimmers and gasping fish behind it. As we now know, this retreat by the water would be followed by a devastating surge back, in which those who escaped drowning risked being smashed by or impaled on crashing debris. Then there would be further surges and withdrawals as though the water was being swirled back and forth in a gigantic glass.

On Sumatra, the waves were said to have been as much as 100 feet (30 m) high, and the island was the place that suffered most casualties, with 94,000 people killed. Altogether Indonesia lost around 166,000 people. Next worst hit was Sri Lanka, with more than 30,000 deaths. A British tourist surfing off the island remembered encountering surprisingly high waves. Then he started to hear screams from the shore. He fought his way back through a 'soup of debris' until he came across the remains of a bridge and clung to it. All around, concrete slabs were being flung into the air like 'pieces of paper'.[16]

Included in the wider disaster here was the worst railway accident in history. The *Queen of the Sea* is a famous train service that operates between Colombo, the capital of Sri Lanka, and the well-known resort town of Galle. Boxing Day, 26 December, was a Buddhist holiday as well as a Christian one, and the train was packed with about 1,500 passengers, many of them children. It reached Peraliya, about 20 miles (32 km) from its destination, just as the beach was being struck by the tsunami. When the train drew to a halt the waters surged around it, and many local people either

climbed on top of the coaches or sheltered behind them. Any hope that this might keep them safe was cruelly disappointed, as another wave sent the train cartwheeling over and over until it finally came to rest on a small hill. An Israeli tourist on board said that he panicked as the carriage flipped over and filled with water. Everything went dark, and he thought: 'This is how you die.' Then the carriage turned over again and he saw that the windows at the front were still above the water. He and a friend managed to get out but they were unable to free a woman and her baby. A 62-year-old restaurateur said that his carriage was flooded very quickly. He was trapped for 45 minutes and thought it was the end, but at last he too was also able to escape through a window. Outside, he found his son and daughter. At first they sought refuge in a temple, but fearing there might be another deadly wave, they trekked uphill for 2 miles to a school. A 25-year-old man from

A man searches the wreckage of his home in the city of Meulaboh on the island of Sumatra, Indonesia, in the wake of the Indian Ocean tsunami of 2004.

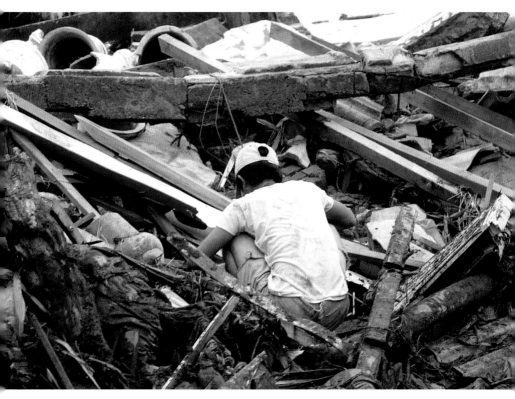

Sussex who had managed to climb on to the roof of a house recalled the second wave breaking: 'I just saw this wall of water coming towards us and then the screaming and the shouting.' In the days that followed, Buddhist monks buried scores of bodies in a mass grave. 'This was the only thing we could do. It was a desperate solution', said one of them. 'The bodies were rotting. We gave them a decent burial.' It is believed that at least 1,700 people died on the train.[17]

From the built-up tourist resorts of Thailand to remote fishing villages in Indonesia, lush green landscape was turned muddy brown in a flash. India lost 9,000 people and Thailand 6,000. Low lying 'paradise' islands like the Maldives and the Andaman and Nicobar Islands were literally swamped. More than 4,000 miles (6,400 km) from the epicentre, 176 people were killed in Somalia. Even further away, eight people died in South Africa, and Durban harbour had to be closed because of the deadly currents the tsunami generated. In addition to the 230,000 people believed to have been killed across the world, millions were left homeless. Survivors complained about the absence of any warning. One said:

> It was not until the ocean disappeared that people were running around saying something was going to happen. There was not even a single phone call, no word of mouth, not even someone running along with a Tannoy system.[18]

But Dr Tim Henstock, a lecturer in oceanography who gave evidence at an inquest into 91 British victims, explained that a warning would have been of little use, because there was no evacuation plan:

> The people who knew the earthquake had happened were not in a position to do anything . . . An early warning system does not help unless you have infrastructure and mechanisms and everyone knows what is supposed to be done if a warning comes.[19]

Nonetheless, on a beach in Phuket, a ten-year-old British school-girl recognized the signs of an approaching tsunami from her geography lessons and managed to persuade her parents and many other people to move to somewhere safer, while in the same resort a Scottish teacher also worked out what was about to happen and got a busload of people driven away to higher ground.

There were some astonishing escapes. In Thailand a two-year-old Swedish toddler was swept from the beach at Khao Lak, then found by an American couple on a road nearby, unscathed apart from a few cuts and bruises. A pregnant Indonesian woman who could not swim was spotted in the sea five days after the disaster, clinging to the trunk of a sago palm tree. She had survived by eating its bark and fruit. There were sharks swimming around, but she 'prayed they wouldn't hurt me'.[20] It was another ten days before a container ship picked up a 21-year-old building worker clinging to driftwood. He had been swept out to sea while he was working by the beach in Sumatra, and told rescuers he had lived on coconuts he found floating in the sea, tearing them open with his teeth. Then, more than a month after the tsunami, nine survivors were found wandering in the jungle in the Nicobar Islands.

The United Nations official in charge of relief, Jan Egeland, was full of praise for the world's initial response, noting that 90 countries, many of them poor, had given aid. He declared, 'I think the world was great in the tsunami', characterizing the response as 'effective, swift and muscular'.[21] He added: 'People got emergency shelter. They got food. They got health facilities.'[22] He went on to add, though, that reconstruction had not proceeded as quickly as he had hoped. In Sumatra and Sri Lanka political con -flicts hampered the effort, and a year later nearly 2 million of the people displaced by the tsunami were still homeless. In Indonesia 67,500 were living in tents, with 50,000 in temporary barracks, while half a million still depended on emergency food rations. About 40 per cent of Sri Lanka's fishing boats were reckoned to have been destroyed, putting their owners out of business, while aid agencies accused governments in Sri Lanka, India, Indonesia, Thailand and the Maldives of discouraging or even preventing those who had lived on the coast from returning to their land, so

that developers could move in and build new tourist resorts. Two years after the disaster it was reported that desperate wives of fishermen in India's Tamil Nadu state were reduced to selling their kidneys to try to make ends meet. Some fishermen were now housed in temporary camps miles away from the sea, unable to get enough time fishing to make a living. The donors often received as little as £400 each for a kidney, with middlemen pocketing a large profit. Following the disaster, work began on a tsunami warning system for the Indian Ocean.

As we have seen, storms can also bring deadly floods. Low-lying and densely populated, Bangladesh often finds itself in their wake as they race up the Bay of Bengal. Only about a quarter of its population of 140 million lives more than 10 feet (3 m) above sea level. The country was still part of Pakistan when a tropical cyclone, with winds of more than 120 miles per hour (195 km/h), sent a huge surge of water to batter it in the early hours of 13 November 1970. Worst hit were the low-lying islands of the Ganges Delta. Kamaluddin Chodhury, a farmer on Manpura Island, said that he heard a great roar and looked outside. Every - thing was pitch black, but in the distance he saw a glow which 'got nearer and nearer and then I realised it was the crest of a huge wave'.[23] He rushed his family up to the roof in the nick of time, as the island disappeared under a 20-foot wave that was soon lapping around their feet. Fortunately their house was more solidly built than most of their neighbours' and it withstood the flood, so for five hours the Chodhury family huddled together as the wind howled and the rain poured. Towards dawn the waters receded, and the survivors found themselves looking out on a scene of utter devastation. Of the 4,500 bamboo huts on the island, only four remained standing. The fields were stripped bare and dead bodies lay on the beaches or hung from trees. An estimated 25,000 people out of the island's total population of 30,000 had perished. On thirteen small islands off Chittagong everyone was killed, while on the neighbouring island of Bhola, the country's biggest, as many as 200,000 people died. In Bangla - desh, too, there were remarkable escapes. A 40-year-old rice farmer survived by clinging to a palm tree. He saw his six children picked

off by the waves one by one. Then he too was swept away, and in despair his wife let go, but the farmer managed to grab another tree and get hold of her. The flood tore off their clothes, leaving them naked. When the waters receded the son of a neighbour gave them a few rags he had taken from trees and corpses. Three days after the flood, another astonishing event. A wooden chest was washed ashore with six children inside. Their grandfather had put them in, then climbed inside himself. They survived, but he died of exposure. More common, though, were stories of unrelieved grief. One old man had to pile the remains of 52 relatives into a single grave. In one village survivors with scarves wrapped around their faces to protect against the smell said they had buried 5,000 people in mass graves, but with so many bodies to deal with some were just put on makeshift rafts and pushed out to sea. Often they were washed back soon afterwards.

Flying over Bhola in the aftermath, a *Times* correspondent reported witnessing local people trying to drag the bloated corpses of cattle to burial pits. He saw a few still alive in the fields but 'without a blade of grass to eat . . . A whole village had disappeared as if sucked up by a huge vacuum cleaner, leaving only muddy outlines of house foundations as evidence of its existence.'[24] A million cattle were drowned, water was polluted and three-quarters of the rice crop destroyed. Taking into account the disease, exposure and starvation that followed, the total number of casualties is put at anything up to 1 million, making this the deadliest flood ever generated by a storm. It also had important political consequences. Local people in what was then East Pakistan complained bitterly at what they saw as the dilatory and grudging response of the national government in faraway West Pakistan, and demonstrations soon turned into a bloody civil war from which the region eventually emerged as the new independent country of Bangladesh. Independence did not put a stop to the floods, though, and in 1991 a cyclone brought another that killed 138,000 people. The cyclone flood of 1970 holds a place in cultural as well as political history: it spawned the first great charity rock concert. The Concert for Bangladesh featured artists such as Ravi Shankar, Bob Dylan, George

Harrison and Eric Clapton, and was the forerunner of events like Live Aid.

Mercifully, many of the world's inhabitants never have to experience hurricanes, cyclones and typhoons, but storms can combine with heavy rain and surging tides to produce deadly floods even in temperate regions, as we have seen in northern Europe. While some of the casualty figures from ancient floods there might prompt a degree of scepticism, we can be sure that a storm surge in 1953 killed 1,850 in the Netherlands as well as another 300 in England. Hurricane-force winds in the North Sea whipped up an already high tide to send a wall of water first against the east coast of England, then against the Netherlands, flooding nearly one-tenth of all the country's agricultural land. The first casualties on the English mainland came on Saturday, 31 January, as 40 people were drowned in Lincolnshire around Mablethorpe and Sutton-on-Sea. Then the waves battered Norfolk, flooding much of King's Lynn to a depth of 6 feet (1.8 m) and killing fifteen people. Jaywick Sands in Essex was popular for its fine beaches, and it had concrete and clay walls to protect its bungalows and chalets, but the flood soon overpowered them.

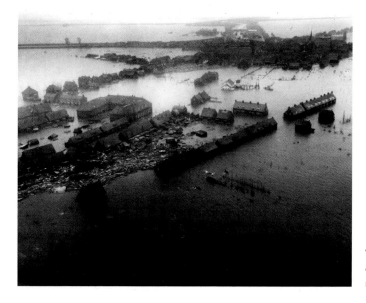

The Dutch floods of 1953 seen from a u.s. Army helicopter.

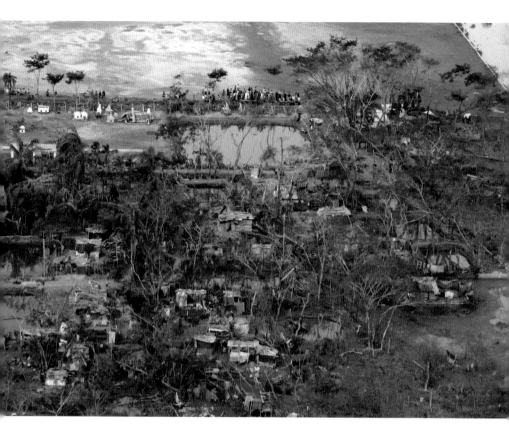

Another Bangladesh flood. Caused by Cyclone Sidr, which swept into the south of the country on 15 November 2007.

One man tried to escape through his front door with his invalid wife and his three-year-old grandchild, but he said that as they pushed it open, 'the full force of the water hit us. I was up to my neck. My wife just disappeared.'[25] He managed to save the child by clinging to a barbed wire fence until help arrived. Another man set out to reach his parents' grocer's shop but was twice beaten back by the swirling waters. He kept telephoning to plead with them to leave and go to the top floor of their house nearby, but they wanted to move their stock on to the top shelves. The last time he rang, he heard his father say: 'The windows are all coming in', and in the background, his mother shouted, 'Save yourself. We're drowning.' Then the line went dead. Thirty-seven people, with an average age of 66, died at Jaywick.

Many had been in bed when the flood struck, and it was the same story further down the coast at Canvey Island, the whole of which lay below the level reached by high spring tides. It was

protected by a 15-mile (24-km) perimeter wall, but many of its dwellings were flimsy holiday homes. At twenty past eleven that night the local police sergeant was warned that there was going to be an unusually high tide, but alerts of this kind were not uncommon, and the storm winds actually seemed to have dropped. But the sea defences on the northeast of the island were lower than in the south, and just before midnight people who were still up saw water starting to come over them. They ran off to warn their neighbours, while men from the local river board tried to raise the alarm by shouting, blowing whistles and knocking on doors, but it was often hard to know which homes were occupied and which had been left empty for the winter. At half past midnight, the first breach in the wall came. A 70-year-old woman who had been awoken by her neighbours and had climbed up to her attic was terrified: 'It was a surging torrent, all manner of things carried by it, including a caravan, several sheds, and any amount of heavy timber ... knocking against the walls and doors like battering rams.'[26] She was fortunate. Most of the islanders were jolted from sleep by the sound of the splintering of glass or the sudden roar of a wall bursting. Debris was now charging by 'as fast as a bus'. The local fire brigade went out to try to raise the alarm but were beaten back by the waters. The telephone operator was told to ring as many people as she could, but the lines were already being torn down.

In their bungalow close to the sea wall the Manser family – mother, father and ten children – were roused at three o'clock by the barking of their dog, by which time the water was already waist-deep. Mr and Mrs Manser, their eldest son Ian, aged fifteen, and thirteen-year-old Christopher tried their best to hold on to the younger children. For a while they were able to stand on pieces of furniture, but as the children screamed and the waters rose relentlessly, the furniture began to float. Five hundred yards (450 m) behind the house was an embankment along which there was a path. Ian decided to swim to it so he could run for help. Meanwhile, Mr Manser tried to keep three children afloat, while Christopher, who could now feel the water reaching his bottom lip, attempted to support another two, but he was getting tired and

finding it hard to keep their faces out of the water. Mrs Manser, who had put the two youngest children in a pram, encouraged the family to sing hymns to keep up their spirits. After a while Mr Manser smashed a hole in the ceiling, and the older children were able to clamber up and straddle the rafters, but the others were left below. Five-year-old Keith fell and banged his head on an iron stove. Christopher dived into the water to try and save him, but the boy was dead. Mrs Manser kept rocking the infants in the pram, and Christopher remembered how peaceful they looked, though later he realized that, with the water so high, it must already have been inside the pram, 'and the two children had just died without making a sound'.[27]

About the time the Mansers were woken, the first outside aid arrived on the island – a fire crew from the mainland. Together with local firemen, they commandeered a dinghy and, using a floorboard as a paddle, rescued fourteen people trapped in their bungalows. By now nearly the whole island was underwater and canoes and tin baths had been pressed into the rescue effort. Soon afterwards the tide began to ebb, and as dawn broke islanders – many of them still barefoot, drenched and in their nightclothes – started heading across the bridge to the mainland on foot, fearful of what the next high tide would bring, while those coming in the opposite direction to help were horrified to find 'a sea where Canvey Island used to be'. By ten o'clock the waters were rising again, but soldiers and local fishermen were all trying to help. An army officer said that survivors were 'full of praise for what was being done for them, and never uttered any word of complaint or moaned about their losses'.[28] A 70-year-old retired ladies' maid had sat alone for twelve hours balanced on the headboard of her bed before a young man from a local yacht club rescued her, but a woman who had been standing in the water with her husband and daughter for thirteen hours died just an hour before help reached them. Two men in a kayak finally got to the Manser family and ferried them one by one to safety. By the time they picked up Christopher, he had been in the water for ten and a half hours and was frozen stiff. He was taken to a house where 'a woman put me in blankets, hot water bottles all around, and

rubbed and rubbed until I came round. How I blessed her!'[29] When he was reunited with his family at a rest centre, he found out for the first time that his brother Ian had survived, but that the three youngest children had perished. On the island there were bodies everywhere – in trees, on bushes and floating in gardens. The authorities decided that the entire population should be evacuated. About 10,000 people left, but 500 stayed. One elderly woman said: 'Hitler didn't get me in the war, and I'm sure Father Thames shan't get me this time.'[30] For a while, it was feared hundreds of lives had been lost, but a systematic search revealed the actual death toll was 58; 43 of them aged over 60. On Tuesday afternoon the last survivor was found – a woman of 76. The total death toll for the UK mainland was 307, and in the inquests that followed there was criticism of the failure to pass on warnings during the hours that it took the flood to travel down the east coast.

Sometimes a flood picks up earth, stones and all manner of debris, acquires the characteristics of fast-moving wet cement, and becomes a mudslide. Perhaps the worst mudslide in history devastated northern Venezuela during the last days of the twentieth century. On 14 December 1999, after two weeks of relentless rain, rivers and streams burst their banks. Flash floods and mudslides careered down either side of the steep mountain range that separates the country's capital, Caracas, from the Caribbean, washing away the shanty towns that clung precariously to the slopes. Flimsy homes had cars hurled through their walls or had their tin roofs crushed by rocks and tree trunks. In one such community, Blandin, nearly a quarter of the 4,000 inhabitants were killed or went missing. One woman, looking for her 71-year-old father, said that he had been inside the house and the water 'just carried him and everything else away. Death is everywhere now ... under my feet and under what is left of this place.' A 52-year-old man who had been a Blandin resident for eleven years said: 'I have lived through one earthquake and other terrible things, but nothing in my life has compared to this. I will never forget the chaos and yelling ... and the loud roar that the floods made. You can never forget something so savage.'[31]

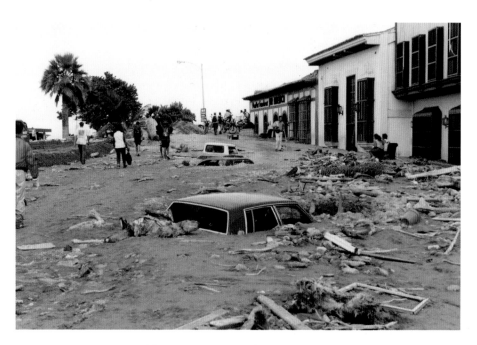

Caracas, aftermath of
Venezuelan mudslide,
December 1999.

But it was not just shanty towns that were hit. Los Corales, a collection of smart apartments close to Caracas's international airport, ended up looking like a lunar landscape; its streets and car parks covered with stones and mud. One local man said that a wall of water, boulders and debris came down the side of the mountain: 'If you were in its way, God help you.'[32] Desperate people headed for beaches littered with tree trunks, and walked around day and night 'like zombies'.[33] Scores, clutching a few belongings, were picked up by navy warships or helicopters. During one rescue flight a woman gave birth. On another a twelve-year-old girl clutched her prized possession – a big tape recorder. Helicopters also landed emergency provisions – canned fish, baby food, water, milk and nappies – as did paratroopers, while dozens of desperate people gathered to carry them off in wheelbarrows and wheelchairs. Altogether 12,000 troops were involved in the rescue effort. Some had to ride into remote mountain areas on horseback to look for survivors. Emergency shelters were soon packed, and so thousands of refugees took mattresses into Caracas's main sports stadium and filled that too. Abandoned houses and stores were

looted. One young man, carrying off a huge frozen tuna on his back as armed soldiers looked on, said: 'This is an emergency. We need food, we take it.'[34] The president Hugo Chávez appealed to those Venezuelans whose dwellings had escaped destruction to take in the homeless. 'The time has come to show that we are all Christians', he said. He and his wife opened the presidential residence to children whose parents were missing.

It is believed that anything up to 30,000 people were killed, but with so many bodies buried deep under mud or washed out to sea, we may never know the true total. Around 23,000 buildings were destroyed and 140,000 people made homeless. The mudslides coincided with a referendum on a new constitution for Venezuela, and critics said that the government ignored warnings of impending disaster, sending police to man polling stations when they could have been helping to evacuate those in harm's way. But even some critics conceded that it might have helped little in the face of such a terrible disaster.

We are used to rain causing floods, but in Peru in 1941 the problem was a heatwave. The inhabitants of the picturesque colonial town of Huaraz had been basking in hot sunshine, with temperatures approaching 30°c. Just over 12 miles (19 km) from the city, and 3,000 feet (900 m) above it, was Lake Palcacocha, filled with more than 3.5 billion gallons of water, held back by a natural dam. Just before dawn on the morning of Saturday, 13 December, a huge lump of ice broke off Mount Palcaraju, a towering peak of more than 20,500 feet (6,250 m), and plunged into the lake. This generated enormous waves that first washed over and then demolished its natural dam, allowing the water to sweep mud, rocks and glacial ice in a deadly mixture down the valley. A few miles further on, it poured into another lake called Jircacocha, rupturing its natural dam. The reinforced flood joined the Quilcay River and headed at up to 30 miles per hour (50 km/h) towards Huaraz, then a city of around 11,000 inhabitants. It surged through a couple of rural communities, causing a few casualties, but most dwellings were high enough above the waters to escape major damage. As the river gathered more debris, a cloud travelled along above it. Those residents of Huaraz who were already

up and about their business – people opening shops or going to church or market – heard a distant guttural roar. Some started screaming – was it an earthquake, a volcanic eruption, an attack? (The Japanese had struck Pearl Harbor just six days before.) In fact it was what is believed to be the deadliest ever flood caused by a glacial lake overflowing. Local people were running in all directions when the wall of water, which was up to 90 feet (27 m) high and now contained trees, houses, livestock and human bodies, thundered into town. Some tried to take refuge on the top of Huaraz's most modern building, a new hotel, but the waters smashed the structure, lifted the roof and tipped them off. The flood would obliterate one-third of the city, destroying houses, a school, the tennis club and the bullring. It ripped a hole in the wall of the prison, allowing inmates to escape, though some drowned in the attempt. Then it carried on for another 135 miles (220 km) beyond Huaraz along the Santa River, destroying more homes and ripping out bridges, plantations and sections of road. Estimates of the number of people killed that day are as high as 7,000. Peru is said to have suffered more than twenty similar, though less deadly, floods over the last 300 years.

Floods have brought suffering and death for many millions of people, but they can also bring important benefits. They renew ponds, sustain wetlands and maintain biodiversity by helping

different plant and animal species to flourish; they also promote the migration of fish and birds. When the Okavango burst its banks in Botswana in 2010, the floods destroyed roads and houses, but they also submerged thousands of acres with nutrient-rich water, drawing thousands of waterbirds to the area, many of species that had not been seen in the region for half a century. On the floodplain around the Ngami River the bird population was estimated to have increased fourfold. And for many people, getting the right kind of flooding is a matter of life and death. On the lower Indus in Pakistan it is only flooding by the river that allows crops to be grown in what would otherwise be a desert. Similarly Egypt was described by the great ancient Greek histor - ian Herodotus as the gift of the Nile. Without the fertile silt the river distributed, that country too would have been an unrelieved desert. Normally the Nile would start to rise in late June until it reached a peak in mid-September, leaving behind a rich layer of nutrients. Around the thirteenth century, the minimum rise in the river needed to produce a good crop was reckoned to be about 28 feet (8.5 m). If it went over 35 feet (10.5 m), there would be serious flooding, but if it failed to reach 28, there was a danger of famine. In 1200, for example, it rose less than 23 feet (7 m), precipitating a terrible hunger which took the lives of at least 110,000 people.

Floods have also created some of the world's most extra-ordinary features, such as the island of Sylt just off the coast of Germany, which is just 600 yards (550 m) wide at its narrowest point and shaped like a capital T on its side. It was formed from the silt snatched up and then dumped by the Grote Mandrenke. Thanks to its inaccessibility and its magnificent beach, the 'St Tropez of the North' is now a playground for the glitterati. The great German novelist Thomas Mann, the painter Wassily Kan-dinsky, Brigitte Bardot and the former Wimbledon champion Michael Stich have all graced the island with their presence. An even more astonishing feature that flooding helped to create is the Petrified Forest in Arizona. More than 200 million years ago, the area was a lush tropical woodland, home to many reptiles and amphibians. Then it was flooded and fallen trees were covered by

silt and mud. This coating slowed down the decay of the logs, while winds carried volcanic ash into the area. The groundwater dissolved silica from the ash, allowing it to seep through the logs filling or replacing the cell walls in the wood so that it crystallized into quartz, preserving the logs as the astonishing objects millions of tourists flock to see today.

Statue of the boy with his finger in the dyke, Madurodam model village,
the Netherlands.

3 Description: Floods in Literature

Perhaps the most famous fictional flood episode in literature concerns one that fails to happen in a book that was never written. Children all over the world have been transfixed by the tale of the little Dutch boy who is on his way home one evening and spots a hole in a dyke, then spends the whole night in the freezing cold blocking it with his finger, knowing that if for a moment he deserts his post, the waters will rush in, bringing disaster to his neighbours and loved ones. To this day we use the phrase 'finger in the dyke' to describe desperate attempts to stave off misfortune. Those who believe the story is true, or at the very least a time-honoured legend, may be forgiven, since a number of Dutch towns, such as Spaarndam and Harlingen, have put up memorials to the little hero.

In fact the tale comes from a book-within-a-book written in 1865 by the American children's writer Mary Mapes Dodge. *Hans Brinker, or the Silver Skates* includes a passage in which a class of schoolchildren read aloud from a work called *The Hero of Haarlem*. It tells how many years ago, there lived in that town an eight-year-old boy of 'of gentle disposition', though we never learn his name. Even little children in the Netherlands, writes Dodge, know that much of the country lies below sea level, and that it is only saved from disastrous floods by big strong dykes, so 'constant watchfulness' is needed. One fine autumn afternoon the boy sets out to take some cakes to an old blind man. On the way home he notices that the waters have been swollen by heavy rain. Because it is starting to get dark, he breaks into a run, but just

at that moment he is startled by the sound of trickling water. Looking up, he sees

> a small hole in the dike through which a tiny stream was flowing. Any child in Holland will shudder at the thought of a *leak in the dike!* The boy understood the danger at a glance. That little hole, if the water were allowed to trickle through, would soon be a large one, and a terrible inundation would be the result. Quick as a flash, he saw his duty.[1]

The boy climbs up the dyke until he reaches the hole, then thrusts in his 'chubby little finger' to stop the flow. At first, he feels a thrill of achievement: 'Haarlem shall not be drowned while *I* am here!' Soon, though, he is aching with cold and trembling with fear. He keeps shouting for help but no one comes. He prays to God 'and the answer came, through a holy resolution – "I will stay here till morning."' The little hero longed to be in his nice warm home, but he knew that if he removed his finger, 'the angry waves, grown angrier still, would rush forth, and never stop until they had swept over the town'. It was a night of torment. 'How can we know the sufferings of that long and fearful watch – what falterings of purpose, what childish terrors came over the boy?' Finally, at daybreak, a clergyman coming home from the bedside of a sick parishioner hears groans as he walks along the top of the dyke, and sees, far below, the boy 'apparently writhing with pain'. He raises the alarm, and help comes at last. Another character in the novel then assures us that the boy's determination to dam a leak is typical of the spirit of the Dutch.[2]

A flood may be only a small element of *Hans Brinker*, but it is the sole subject of a novella, *The Flood*, written by the French Naturalist writer Emile Zola in 1880. It is a tense, straightforward description of the ordeal of Louis Roubien, a 70-year-old great-grandfather from Saint-Jory, a few miles from Toulouse on the Garonne river. He lives on a farm with his brother Pierre, his sister Agathe, his son Jacques and Jacques' wife Rose, and their three daughters – one of whom, Aimée, is married to Cyprien, by

The Garonne. A weir at Toulouse.

whom she has two young children. Aimée's sister, Veronique, is soon to marry Gaspard, a young man of prodigious strength. Louis has prospered, so that the farm 'sang from every corner'. Indeed, whenever his neighbours' vines fell sick, his own appeared 'to have a wall of protection around them'. His son teases him that he must be 'a friend of the Divine Power', but Louis had begun to feel it was no more than he deserved: 'Never doing harm to any one, I thought that happiness was my due.' The action takes place one beautiful May evening when Gaspard has come to dinner to make arrangements for the wedding. They sing, celebrate and drink good wine, though the young man mentions that some people are concerned about heavy rain swelling the Garonne. Not Louis, though. Pointing to the lovely blue sky, he replies that it is the same every year: 'The river puts up her back as if she were furious, and she calms down in a night.' The evening

is filled with idyllic sounds – a laughing neighbour, children play-
ing, livestock going into their sheds. Then suddenly a shout goes
up: 'The Garonne! The Garonne!'[3]

Saint-Jory lies in a hollow from which the river cannot be
seen, so the first alarming sight to greet the family is the appear-
ance of two men and three women, one of whom is carrying a
child, running along the road 'as if a band of wolves was pursuing
them'. In the distance behind them appears 'what looked like a
pack of grey beasts speckled with yellow. They sprang up from
all directions, waves crowding waves, a helter-skelter of masses of
foaming water, shaking the sod with the rumbling gallop of
their hordes.' For Louis, the flood is not a natural phenomenon,
but a malevolent 'charging battalion' that seemed 'to pursue the
fugitives'. Soon it caught them, swirled about their knees, then
engulfed them. At once, the patriarch hurries his family into the
upper floor of the house: 'It is solid – we have nothing to fear.' In
no time the waters are in the yard below, but Jacques puts a brave
face on things, saying that this has happened before, and that the
river soon receded. Louis has noticed, though, that as the flood has
taken over the village streets, it has changed its tactics; 'no longer
a galloping charge, but a slow and invincible strangulation'. The
men stand by the windows trying to block out the visual evidence,
but the terrified cries of the farm animals below as they struggle
and drown draw the women over, and the reality can be hidden no
longer. As the waters rise relentlessly to the upstairs window,
there is sobbing and tears. By now, Louis' view of God has changed.
He shakes his fist, declaring, 'We had done nothing against Him,
and He was taking everything from us!' Then he reflects that
money does not matter and that the important thing is that every-
one is safe, while Jacques says they must get up on the roof, still
confident that the strong house will protect them.[4]

By the time they climb up, the family can no longer see any
dry land, and soon the water is only 3 feet below them, but Louis
thinks that rescue boats will surely come from neighbouring
villages once they see what is happening. All the time the flood is
getting more menacing. Dangerous currents appear, trees are
felled and buildings crumble, while the waters dash debris against

the house. What are they to do? Gaspard offers to swim somewhere safe with Véronique on his back and get help. Louis' brother Pierre suggests making a raft. Then Cyprien says they must try to reach the church tower by climbing over the roofs of houses. He will set out first to see if the route is safe, but Aimée insists on taking the children and going with him. The rest of the family watch as they successfully negotiate the first two roofs. The third is steep, and they have to go on hands and knees. The next stands at least 10 feet higher, but with great agility, Cyprien manages to shin up a drainpipe, while Aimée and the children wait. Then, as Cyprien crosses the roof, it collapses, trapping the poor man upside down with his feet between two beams and his head just above the rising water. Aimée, watching below, howls in anguish. Before the other men can try to save him, one of the houses in between crumbles too, and all they can do is watch as Cyprien is drowned with agonizing slowness.

The family are not given long to dwell on their loss. Now the water is up to their roof tiles, and beams from destroyed buildings are hammering their walls like battering-rams. While the women weep, Gaspard, Jacques and Pierre try to fend off the waterborne missiles, but they are overcome by the power of the river, invincible in its 'tranquil obstinacy'.[5] In the distance they can hear voices, and see lanterns on boats, and Gaspard spots the roof of a shed, floating by like a raft. He leaps on to it and shouts to Louis that they are saved. Then he manages to get Véronique, her sister Marie, Rose and Agathe aboard, followed by the men, saying that they will pick up Aimée, who is still leaning against a chimney and holding her children out of the water, which now reaches her waist. Using poles they finally manage to push the improvised raft away from the house, but as they break clear, they can see how deadly is the current they will have to negotiate to reach Aimée. Louis is in agony. The rescue attempt is putting eight lives at risk. While Gaspard tries to manoeuvre them towards the marooned woman, the current flings them back against the house, smashing the raft to bits and plunging everyone into the water. Pierre drags Louis on to the roof by his hair, and he and Gaspard manage to rescue Véronique and Marie, but

Agathe, Jacques and Rose all drown. On the other roof a little way off, the waters finally close over Aimée and her children.

The five remaining survivors are now confined to a narrow island at the top of the roof. Worried that it is going to collapse under their weight, Pierre throws himself into the waters to give the other four a better chance. At two in the morning, with their refuge getting smaller by the minute, Gaspard says he will swim with Véronique to the church which still rises above the flood, find a boat, and come back for Louis and Marie. He puts a rope around Veronique, then slides into the water. At times, her weight pushes him under, but he carries on swimming with superhuman strength. Then, when he has covered about a third of the distance to the church, they are struck by debris, and disappear beneath the water. From that moment, Louis is 'stupefied', having only 'the instinct of the animal looking out for its own safety'. The other survivor, Marie, driven mad by the horrific events, slips into the water and drowns, and that is the last thing Louis remembers. He learns later that people came from a neighbouring village at six in the morning and found him lying unconscious, but he wishes that he too had perished: 'All the others are gone! The babes in swaddling clothes, the girls to be married, the young married couples, the old married couples. And I, I live like a useless weed, coarse and dried.'[6] He goes to Toulouse to try to find the bodies of his loved ones, and discovers that 700 people have been drowned. Zola's story was based on a real flood of the Garonne five years earlier, and it is possible to identify reported incidents from that event that may have influenced his account – such as a farmer's family seeking refuge on a roof only for them all to perish, or the fourteen people drowned in a boat that overturned, with the only survivor a fifteen-year-old girl who lost her reason.

Alexander Pushkin's poem 'The Bronze Horseman' is also inspired by a real event – the inundation that devastated St Petersburg in November 1824, killing several hundred people. *The Times* noted that 'the inferior classes of the people in particular have been victims'.[7] But while Zola's account is 'Naturalist', Pushkin's is wildly imaginative. The work opens with a celebration of Peter the Great's achievement in building this noble city

a century before on the banks of the River Neva, where previously there had been only a few scattered hovels. Then the poem moves on to a dark November night when the wind howled and the Neva 'tossed like a sick man in his restless bed'. The emotional turmoil of the poem's hero, Yevgeny, echoes the storm as he tosses and turns on his bed, bemoaning his poverty. He is tormented even more because the swollen waters will stop him going to see his beloved Parasha. The next morning, the river is 'bubbling like a cauldron' hurling itself on the city 'with the frenzy of a beast', and soon St Petersburg is waist-deep in water. Like Louis in Zola's novel, Pushkin begins to transform the flood into a conscious entity as 'evil waves climb like thieves through the windows'. Soon fragments of huts, beams, roofs, bridges, coffins, 'the wares of thrifty trading and the chattels of pale poverty' are afloat in the streets, while people 'gaze on the wrath of God and wait their doom'. As squares become lakes, the tsar's palace is left like a melancholy island. He comes on to his balcony, 'sad and troubled' and acknowledges that even 'tsars cannot master the divine elem - ents'. Meanwhile, Yevgeny clambers on to a marble lion, heedless of the water lapping his feet and the rain lashing his face, because his eyes are fixed on a distant point where he hopes to glimpse the humble house in which his beloved lives with her widowed mother. Instead he is horrified to see waves like mountains, a howling storm, and debris being driven to and fro. Impassively surveying this turbulent spectacle from high above stands the imposing statue of Peter the Great, the Bronze Horseman. Zola's flood had the relentless military precision of a battalion. Pushkin gives his the more random menace of the bandit: 'Thus a marauder, bursting upon a village with his savage band, smash-es, slashes, shatters and robs . . . And weighed down with their plunder, fearing pursuit, exhausted, the robbers hasten home, dropping their plunder on the way.'[8]

When the Neva 'satiated with destruction',[9] begins to subside, Yevgeny sets off to find Parasha, persuading a boatman to take him across the still unruly waters. Many times their skiff is almost overturned, but at last they reach the far side. The young man runs down to the street where his beloved lived but sees nothing

he recognizes. Everything has been 'hurled down' or 'torn away'. The place is like a battlefield, with dead bodies everywhere. He begins talking to himself, slaps his forehead and then bursts out laughing. Finally, 'exhausted by torments', Yevgeny runs away. When he gets back to St Petersburg, normality has returned, but the hero's mind has been overturned by the terrible shock he has suffered, and he wanders the streets a tramp, his clothes shabby and torn. Children throw stones at him, and he lives on morsels of food handed to him through windows. His imagination becomes haunted by the Bronze Horseman, and he curses its subject for founding the city so near the waters that killed the woman he loved. Then he flees and runs all night, believing he can hear Peter the Great on his steed thundering behind him.

The 'Bronze Horseman'. The equestrian statue of Peter the Great, St Petersburg.

66

Finally Yevgeny takes refuge in a derelict hut on an uninhabited island in the river, and that is where his body is found one day.

In Pushkin's poem the hero is driven into mental breakdown by the flood, but in other works of literature the violence of the waters matches the inner turmoil already tormenting the central character. During George Eliot's novel *The Mill on the Floss*, published in 1860, Maggie Tulliver becomes estranged from her older brother, Tom, and then falls in love with the fiancé of her best friend, Lucy. She runs away with him, but turns back, and returns to live an outcast in her village of St Ogg's. At the climax of the novel, she is sitting alone one night, reading letters, when she hears heavy rain being driven against the window by a 'rushing, loud-moaning wind'. The rain has been falling for two days, and the older inhabitants have been talking about a flood of the River Floss 60 years before that had caused great misery. The letters carry fresh bad news. One from the local clergyman advises her to leave the area because of the discord her presence is causing, while another from Lucy's fiancé reproaches Maggie for breaking it off with him, and begs her to come back. In her desperation she is tempted, but tells herself that she has been allotted a cross that

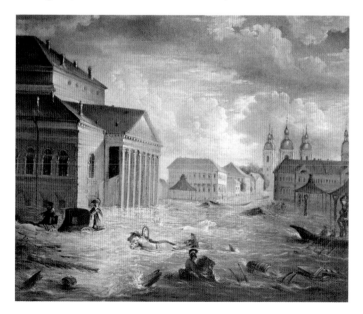

The St Petersburg flood, 1824.

she must bear until death. Then her mood swings again and she wonders whether she really can bear this fate. While she is agonizing, she feels her feet getting cold and wet. Water is flowing under her door. It is the flood! She wakes the couple in whose house she is staying, then something crashes against the window, shattering it, and the water pours in. She escapes into a boat and begins to row. The rain has stopped now, but she is being carried out on the flood – 'that awful visitation of God'. Maggie desperately wants to get to her old home at Dorlcote Mill to see that Tom is safe, but she cannot tell in which direction she is going. When she finally manages to find the house, the ground floor is flooded, but Tom climbs into the boat from an upstairs window.[10]

Illustration of Tom and Maggie Tulliver from *The Mill on the Floss* (1860) by George Eliot, 1910.

Now he takes over the oars, and they row off to try to rescue Lucy, but the water is getting much more dangerous as it picks up debris. People in another boat shout to them to get out of the current as an enormous piece of machinery heads towards them, but it is too late. Tom sees that they are about to be sunk. He throws down his oars and grabs Maggie in his arms: 'The next instant the boat was no longer seen upon the water – and the huge mass was hurrying on in hideous triumph.' Tom and Maggie 'had gone down in an embrace never to be parted', and would be buried together. Five years later, notes Eliot, there was hardly a trace of the desolation wrought by the flood: 'Nature repairs her ravages – repairs them with her sunshine and with human labour.'[11]

A flood also comes at the climax of *Gormenghast*, the second novel in the famous surreal trilogy by Mervyn Peake, mirroring a crisis in the life of its hero, Titus Groan. The castle of Gormenghast is threatened by a deadly enemy, Steerpike, who wishes to

take supreme power and is roaming undetected through its labyrinthine depths, a constant threat to life and limb with his lethal catapult. Meanwhile, seventeen-year-old Titus, the earl of Gormenghast, is tormented by the pangs of first love, having become entranced by 'the Thing', a feral girl who is the daughter of his former wet-nurse. While he is wandering outside the castle, the first drops of 'the great rain' fall: 'This was no ordinary downpour. Even the first streaks from the sky were things that lashed and kicked the dust out of the ground'. In spite of its violence, though, there was 'no sense of hurry about the rain. It gave the impression of an endless reserve of sky-wide energy.' Titus decides to run to the forest to shelter. With the rain now like 'a tap turned to its full', the water is soon up to his ankles. He manages to splash his way through to a cave and falls asleep. When he wakes, he catches a glimpse of the Thing, but when she sees him she hurls a stone at him and runs off. As she falls from a ledge, he catches her and holds her for a moment, but she wriggles out of the shirt she is wearing and escapes naked out of the cave. Titus catches a brief glimpse of her, and then a flash of lightning burns her up like 'a dry leaf'. Like Maggie in *The Mill on the Floss*, Titus also has a sibling from whom he is estranged – his sister, Fuchsia. She comes to the cave and tells him he must return to the castle because the flood is rising. After a terrifying journey through waist-deep water, they reach their objective and clasp each other: 'For a fleeting moment . . . they were brother and sister again.'[12]

By then, the water inside the castle is 'like a dark and slowly moving carpet', and the ground floor has already been evacuated. At the foot of one of Gormenghast's great stairways, exhausted men sleep surrounded by piles of books and furniture. Outside now is a vast expanse of water, and fish are swimming in through the castle's lowest windows. Livestock have been brought inside the building while wild birds and animals are taking refuge on Gormenghast mountain. Still the waters rise, and soon the first and second floors have to be abandoned. Many people drown while survivors continue the 'backbreaking business of forcing a world of belongings up the scores of stairways.' One of the most difficult tasks is to drive up panicking cattle who break banisters

and bend railings, but not everything can be saved. The armoury becomes 'a red pond of rust' and books turn to pulp, while pictures float eerily along corridors. And still the waters creep upwards 'like terror, inch by clammy inch', while the skilled Bright Carvers busily make boats from whatever wood can be stripped from the building. It is two weeks before the rain stops, and by then the upper storeys are so overcrowded that encampments have to be set up on the roofs, while an improvised hospital in one of the attics is filled with the exhausted, the sick and the injured. Titus, meanwhile, finds it exhilarating to row through the corridors and galleries in the craft that the Carvers have built for him, but the villain Steerpike has also been worming his way into the upper floors of the castle, using his encyclopaedic knowledge of its intricate geography to remain undetected.[13]

Titus's mother, the Countess, is determined to track their enemy down before the waters recede, believing that never again will she have him in such a tight net, and she launches a full-scale manhunt. Steerpike kills a number of his pursuers before Titus slays him. And the rain stops. The floodwater that has caused such havoc lies 'innocently, basking, as though butter would not melt in its soft, blue mouth', but, as in so many real floods, it had left behind disgusting devastation. In the castle 'filthy slime lay a foot deep across great tracts of storeys'. Indeed, a year later Gormenghast is still 'dank and foul', while a shanty town of huts and shacks have grown up around it.[14] The way a flood sets reality on its head, which so fascinated Peake, with phenomena like fish swimming in through castle windows, has also intrigued other writers, such as the seventeenth-century poet Andrew Marvell. In 'Upon Appleton House' he described the strangeness of a meadow becoming a sea:

How Boats can over Bridges sail;
And Fishes do the Stables scale.[15]

In William Faulkner's novel *Old Man* (which also appeared as *The Old Man*), written in 1939, the flood itself is less important than its aftermath, which provides a means of exploring the psyche of

one man, an unnamed, 'lean' 25-year-old convict. The backdrop of the story is a real event – the great Mississippi flood of 1927, when the river burst through its dykes in nearly 250 places, spread 60 miles (95 km), killed 300 people and left nearly 650,000 homeless. The convict is serving fifteen years in jail for a bungled train robbery he committed when he was eighteen. He is sent off in a boat with another prisoner to rescue a woman in a tree and a man on a cotton-house roof. They soon get into difficulties in treacherous currents, and the hero is thrown overboard while the second man hangs on to a tree. He is later picked up, believing the lean convict has drowned. In fact the hero has managed to climb back into the skiff and then rescue the woman, who is heavily pregnant. He cannot find the man on the roof. After a day on the water without food, he and the woman have found no land by the time darkness falls. Then the convict hears a sound: 'He had never heard it before and he would never be expected to hear such again since it is not given to every man to hear such at all and to none to hear it more than once in his life.'[16] Accompanying the noise is a sight that those out at sea in a tsunami would recognize: 'the sharp line where the phosphorescent water met the darkness was now about ten feet higher than it had been an instant before', while the crest of the wave swelled 'like the mane of a galloping horse' and 'fretted and flickered like fire'. It brought rushing with it all manner of debris – planks, small buildings, trees and dead animals. The skiff seemed to stand for a moment on its stern, then successfully mounted the wave as the objects raced past.

The novel does not depict any friendship or even much conversation between the hero and the woman, but he feels a

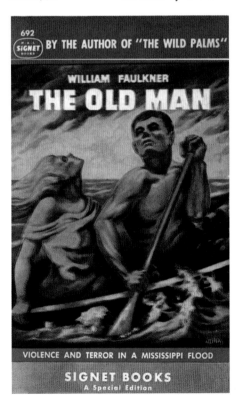

Cover of William Faulkner, *The Old Man*, 1948.

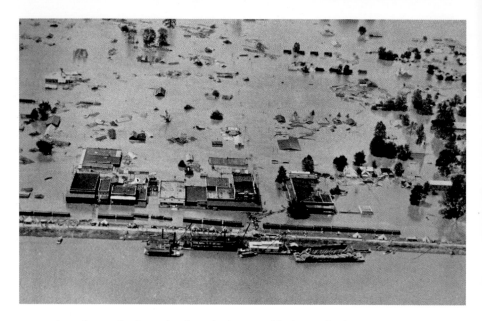

strong impulse to do the right thing by her – to 'find somebody, anybody he could surrender her to'. To stave off starvation, he pulls a dead hen from the water and eats part of it raw, but the woman turns down his offer to share it. As the skiff is driven across the state border from Mississippi into Louisiana, they manage to pick up food from other boats they meet. At Baton Rouge the convict sees a group of figures in khaki and tries to surrender to them, but they fire on him, wounding his hand, and he rows off again. After they have been on the water 'for more days and nights than he could remember', they are washed up on a tiny piece of land, and on 'that quarter-acre mound, that earthen-ark out of Genesis', she gives birth. The convict gathers what food he can and makes a new paddle for the boat, and after a few days they set off again. This time they are picked up by a steamboat. Some of those on board are surprised the hero is still wearing his convict's uniform, destroying his best chance of escape, but he is still determined to give himself up, and is put ashore at a levee. A doctor offers him money, but he refuses it.[17]

From the levee, he drags the woman and baby overland in the boat for a time. Then he rows them to a bayou where they spend a few days in a decaying house on stilts with a Cajun man they cannot understand, as he speaks only French. The two men

Arkansas City during the great Mississippi flood of 1927.

hunt alligators together, making a little money, and the convict remembers how satisfying it is to work for pay. He changes into a pair of ragged dungarees he gets from his host, but makes the woman wash his convict's uniform and keep it safe. One day there is a lot of commotion outside, but because everyone is speaking French neither the convict nor the woman understand. The Cajun tries to warn them about something, and the next morning he leaves, but the convict is determined to stay on. Then, on his return from his next alligator hunt, he sees a launch by the house into which the woman is climbing with her baby, and fears his 'citadel ... the very crux and dear breath of his life – the being allowed to work and earn money' is under threat. The men in the launch ask why they did not leave the previous day when they were warned that a hole was going to be blown in the levee. They have to overpower the convict to get him into the launch and keep him manacled to stop him trying to escape, but he persuades them to take his boat onboard. The launch drops them off at a town where they are taken to a refugee centre and fed and clothed, but at night they climb out of a window, and set off again in the boat. The convict carries on rowing back to Mississippi, taking the odd job along the way, until finally he finds a deputy sheriff and gives himself up, saying: 'Yonder's your boat, and here's the woman. But I never did find that bastard on the cotton-house.' He has his sentence increased by ten years for trying to escape. The warden says: 'It's hard luck. I'm sorry.' The convict makes no protest: 'All right. If that's the rule.'[18]

Idiosyncratic it may be, but Faulkner's novel paints a realistic picture of the aftermath of a flood. The years since the Second World War, though, have witnessed a growing literary interest in imaginary apocalyptic deluges. Was it because of the atom bomb, which lies at the heart of Bernard Malamud's novel *God's Grace*, published in 1982? A Jewish palaeontologist named Calvin Cohn happens to be exploring the ocean bed when a nuclear war, followed by a 'Second Flood', carries off the rest of humanity. When he comes back to his ark, the support vessel on the surface, this holocaust is over, and God tells him through a gap in the clouds that his escape from universal destruction is the

result of a 'minuscule error'. Calvin argues that after Noah, God had promised never again to flood the world, but the Almighty retorts that human beings have brought this fate on themselves. Not only did they invent nuclear weapons but they polluted the earth and 'tore apart my ozone . . . acidified my refreshing rain'. Calvin asks if he can be allowed to go on living, but God replies, 'No Noah this time, no exceptions.' As the last human sails along, not knowing where he is, he discovers aboard the ship a bright chimpanzee which he names Buz and adopts as his son. They run aground on a tropical island, and Cohn and Buz set up home in a cave. In spite of the nuclear holocaust, vegetation is growing on the island, though there appears to be a drowned village off the coast, presumably a victim of the Flood. Soon other primates begin to appear – a gorilla, more chimpanzees and baboons. As rather miraculous things start to happen – delicious fruit grows plentifully, the chimps learn to speak – Calvin begins to wonder whether the island is a second Garden of Eden.[19] If Calvin does something that displeases Him, God makes the occasional demonstration with a peal of thunder or a pillar of fire.

The palaeontologist and a female chimp become mutually attracted, and they breed, producing a bright young daughter. For a while the community works well together, but then some of the chimps kill and eat a baby baboon. When Calvin reproaches them, telling them they are following the same disastrous route as man, they protest that this is the natural thing for chimpanzees to do, and that baboons taste better than fruit and vegetables. There follows a revolt by the chimps who then lose the power of speech, and the novel ends with another biblical echo – this time of the story of Abraham and Isaac, as Buz and the chimps take Calvin up a mountain to sacrifice him.

Penelope Lively's children's story *The Voyage of QV66*, published four years before Malamud's novel, is also a modern reworking of the story of Noah. Its characters are a motley collection of animals and birds, like the edited highlights of the great menagerie on the biblical ark. It has fewer overt allusions to religion than *God's Grace*, though one character, Offa, a pigeon who used to live on Lichfield Cathedral, does keep quoting from the scriptures.

There are no people left in England, and the narrator, a dog
named Pal, supposes they must have left 'when the water came'
and that it 'must have come very fast, because they went just like
that, without taking much with them'.[20] The brightest of the crew
is Stanley, a monkey. He finds old newspapers carrying stories
of a mass evacuation of humans to Mars planned by America and
Russia. At Carlisle, the group commandeer a boat marked 'QV66
Property of the Port of London Authority'. Stanley, who has seen
a picture of someone like himself on a poster for London Zoo,
persuades them to try to get to the capital. Many roads are still
flooded and rivers and streams have turned into lakes, but as
they travel south the water level starts to fall. The boat becomes
not only a means of transport, 'but a kind of home as well', and
they encounter a world very different from their own example
of interspecies cooperation. Many animals are in a state of war.
The group have to fight hostile dogs who have taken over parts
of Manchester, and foil a sinister band of crows known as the
'Wise Ones' who capture one of their number, a cat, and try to
sacrifice her at Stonehenge on Midsummer's Day. By the time
the *QV66* fraternity get down to London, the floods have more
or less dispersed and the landscape has gone back to what it was
like before the people left, but the zoo proves sorely disappoint-
ing. It is dominated by bureaucracy and regulations, and filled
with animals who spend all their time working feverishly on
pointless projects. Pal and his friends go back to the QV66 and
resolve to look for something better.

We never discover what caused the flood in *The Voyage of QV66*,
but in J. G. Ballard's novel *The Drowned World* (1962), the cause
is global warming, though not of the kind that generates most
concern today. The year is 2145, and biologist Dr Robert Kerans
is a member of a scientific team run by an army officer, Colonel
Briggs, in what is left of London. His quarters are a suite on
what was once the top floor of the Ritz, but which now has what
is termed a 'lagoon' right outside the door (although on a holiday
review website it might get described as a filthy swamp filled with
rubbish). The lower storeys of the hotel, along with most of London's
other buildings, are submerged, and Kerans regards his suite as

one of the last relics of a civilization 'now virtually vanished forever'. The great flood that killed it came when the polar ice caps melted following a dramatic increase in temperature caused by a prolonged series of violent solar storms. The equator and the tropics have become uninhabitable because of unbearable heat, while even in London the midday temperature is 130 degrees. The air is full of predatory insects, like mosquitoes the size of dragonflies, and some of the few remaining people suffer from novel forms of malaria, while giant lizards and crocodiles roam the city. London is soon going to have to be evacuated because of belts of fierce rain moving up from southern latitudes. Overall, the earth is going back to what it was like in the age of the dinosaurs, turning into a kind of 'insane Eden'. Kerans has a few friends left, but he is systematically withdrawing from human contact because he believes this is essential 'preparation for a radically new environment'. When Colonel Briggs orders the evacuation, Kerans, a colleague named Dr Bodkin and a woman who lives nearby all decide to stay.[21]

A few weeks later a hydrofoil turns up accompanied by a flotilla of smaller boats, carrying a bunch of freebooters, who make their living by looting goods from drowned cities. They set up powerful pumps to empty the lagoon, revealing what used to be central London, though much of it is covered in silt, and build a huge wooden barrage to keep the waters out. The three who have stayed are horrified at the destruction of what has become their world, and Bodkin tries to blow up the dam, but the freebooters shoot him as he is planting the bomb. Kerans has also been earmarked for death, but Colonel Briggs comes back to rescue him. The biologist asks the colonel when he is going to re-flood the lagoon, but Briggs gives him short shrift, saying the freebooters will be emptying more lagoons and that theirs is top-priority work. When Kerans tries to blow a hole in the barrage, Briggs's men shoot and wound him, but he escapes and then sets off to sail south, towards the heat, in a catamaran he has made from oil drums. The novel ends nearly a month later with Kerans still travelling on in spite of his injured leg and the attacks of alligators and giant bats – 'a second Adam searching for the forgotten paradises of the reborn sun'.[22]

Civilization lies buried
beneath the stagnant seas of

BERKLEY

F655
50¢

THE
DROWNED
WORLD

J. G. BALLARD

A BERKLEY ORIGINAL

J. G. Ballard, *The Drowned World* (1962).

We assume that climate change of the kind with which we are familiar is behind the dramatic events of another apocalyptic novel, Maggie Gee's *The Flood*, published in 2004. Once again London is the location, but much of it has been covered by 'stained waters' after months of rain. Some of the context sounds familiar. The government is led by the forty-something prime minister Mr Bliss, said to have 'the evangelist's air of a man who believes, whose mission to convince himself has been too successful'. He has fomented an unpopular war with a faraway Muslim country, and there are bombings on the Tube, while the intelligence services churn out dossiers on how dangerous the enemy is. Rich Londoners have congregated in the higher parts of the city while the poor are confined to tower blocks in the rest. The lower storeys of these are flooded and power often fails for days on end amid rumours that the authorities are diverting the waters their way. The floods have brought a revival of religious fundamentalism, with sects like the Brothers and Sisters of the Last Days telling the story of Noah and denouncing sinners such as painted women, celebrities, drug-takers, stockbrokers and lazy foreigners, who have brought destruction on the city. They win plenty of support among the downtrodden. At the same time, a television celebrity scientist is propounding a theory that an unusual alignment of the planets will lead to massive tidal waves.[23]

As the waters continue to rise, even the areas where the rich live begin to be submerged. Schools are shut, roofs fall in because of the weight of water on them and any journey becomes a nightmare because so many streets are closed. A bus is swept away, killing more than 50 people. The economy is collapsing, and inhabitants of the tower blocks are reduced to bartering.

If they ever leave their homes they can expect them to be looted. Finally the rain relents, and the government mounts a big clean-up to prepare for a huge celebration gala in spite of prophesies – religious and scientific – that the world will end the next day. And by the time the gala is over, the waters are rising again. Bliss claims that a foreign power is sabotaging flood defences and launches a pre-emptive strike against it. As the rich begin trying to flee the city, suddenly, 'with an unearthly roar, with a schloop-ing sound as if giant dinosaurs are sucking the drains', the flood disappears, and dirty water pours back into the sea, dragging with it cars and buses, sheds and lawnmowers. Gee's novel was written before the Boxing Day Tsunami, but now, of course, we recognize that this is just the first phase of a catastrophe. The next thing to happen is the appearance of a 'white line of water, moving in from very far away'. People run to take refuge on Daffodil Hill, the highest point of the city, but the wave carries them all off.[24]

At first, global warming also appears to be the world's prob-lem in Stephen Baxter's novel of 2008, *Flood*. This is an epic tale that spans four decades and most of the world, but again much of the early action happens in London. The year is 2016. Much of the city, and of England, is underwater, and the country is covered in refugee camps for people displaced by the floods. We learn that similar things are happening in Spain and Australia, that the Polynesian islands of Tuvalu have been obliterated and that the rises in sea level, exacerbated in London by heavy rain, are much more rapid than anything that had been forecast – 'climate change on speed',[25] some are saying. As in Maggie Gee's novel, religious fundamentalism, sometimes violent, is on the increase. The Thames Flood Barrier is now raised most of the time, though angry protestors complain that billions are being spent on defending the capital while the rest of the country is left to its own devices. In a supposedly once-in-a-thousand-years event, flood defences are overwhelmed on both sides of the river, and water pours over the barrier. Soon the Thames Valley has turned into an archipelago.

By 2017 the rise in sea level has reached 5 m. Liverpool has been abandoned, and Cambridge is on the coast. In other parts

of the world, wars break out as people fight for the diminishing supply of land. Meanwhile, beneath the sea off Iceland, an oceanographer named Thandie Jones gets caught in some kind of fountain. In an echo of Noah's flood, when 'all the fountains of the great deep [were] broken up', we are told that it feels like 'water bubbling up from the interior of the Earth'.[26] Thandie remembers theories about subterranean seas trapped in porous rock beneath the ocean bed, and begins to think this, not climate change, must be causing the rise in sea level. She gives the sunken oceans names like Utnapishtim and Deucalion. The water that is coming up is hot, and as the ocean warms up, so does the world's temperature. A hurricane devastates New York City. By 2019 Britain is flooded to a depth of 30 m. Exotic tropical diseases have appeared, and law and order have broken down, with independent fiefdoms surrounded by barbed wire occupying the higher ground. The same thing happens in America, where it is said that more people have been shot dead at illegal roadblocks than have been killed by the rising waters. One of the novel's main characters, a self-seeking but visionary tycoon named Nathan Lammockson, declares: 'Earth has itself intervened in human affairs, trying to shake us off as a dog shakes off a flea.' Before the flood, 2 billion people had lived at less than 100 m above sea level, and by 2025 the waters have risen 200 m.

Lammockson moves his headquarters to the ancient Inca capital Cusco in Peru, 3,400 m up. Like most surviving cities, it consists of a rich 'Green Zone' surrounded by shanty towns. North and West Africa have been flooded; Australia has all but disappeared. There is no respite, as by 2031 the sea has climbed 400 m, devouring 40 per cent of the pre-deluge land – home to 4 billion people. More and more of the surviving human beings have to live on rafts. Some are enormous and even carry miniature farms. By 2035 a new Inca Empire has emerged in what is left of South America, and its forces take Lammockson's headquarters, but his men deploy a genetically specific poison gas that holds off the enemy long enough for him to escape. With great foresight, the entrepreneur had already built a replica of the *Queen Mary*, which he calls *Ark Three*, and which carries a bio-bank of grass seeds

and pig embryos. There are rumours of other 'Arks' but even Lammockson does not know what they are. *Ark Three* is described by one of the 3,000 people aboard as the 'floating hotel at the end of the world', but this is no pleasure cruise. Everyone has to work, harvesting whatever can be salvaged from the great islands of debris floating on the sea – made up mainly of plastic rubbish along with the odd bloated human corpse.

North Face of Mount Everest, Tibet.

By now England has completely disappeared. Small parts of the Scottish Highlands and Welsh mountains are left, but they are infested with bandits. Switzerland has the only remaining functioning government in Europe. Kathmandu, still about 400 m above sea level, is now one of the richest places on earth, but Russia, China and India have fought a nuclear war over Tibet, and a 'hardline' Maoist regime has taken over there, farming people to be eaten. By 2041 most of the raft communities *Ark*

Three comes across are starving, and with floodwater now more than a mile deep, very little is left of the United States. *Ark Three* gets torpedoed by pirates, and the last remaining u.s. warship salvages its seed store. Having foreseen the dangerWomen's Pioneer have behaved even since her mother's death of this too, Lammockson had constructed a number of huge rafts out of fibres and emulsions created from genetically engineered algae. As more and more land disappears, most of the human population has perished, but on the remaining rafts are children who have grown up knowing only life on the water, and hop in and out of it like seals. The final piece of land, the summit of Mount Everest, disappears beneath the waters in May 2052. One of the characters says that he believes the earth is going through a whole new evolutionary phase, turning into a planet of water, where higher global temperatures will cause fierce storms and whip up the sea, generating new forms of life by stirring up the nutrients. In most apocalyptic flood stories the final phase is the repopulation of the earth by surviving humans. Not this one. *Ark One*, it emerges, is a starship, and there are stories that it has been seen flying off, carrying a few chosen humans into space.

4 Depiction: Floods in Art and Films

Michelangelo, Raphael, Breughel, Poussin, Turner, Géricault, Dalí, David LaChapelle: what do these artists have in common? The answer is that all of them have depicted Noah's flood, as have numerous others. In fact the deluge was one of the first subjects featured in Christian art, depicted as early as the third century on the walls of the catacombs beneath Rome. In these ancient murals the ark sometimes appears as a small floating cask in which Noah stands alone, his arms raised in a pleading gesture. Depictions of the destructive power of the flood came later. One of the first is in an eleventh-century French illuminated manuscript by Stephanus Garsia Placidus showing the drowned bodies of men and animals. By the Middle Ages the flood had become a common subject on the walls of cathedrals, with notable examples at Bourges, Wells and Salisbury. At Bourges the sculptor did not gloss over the suffering the deluge brought, portraying corpses floating in the waters. During the Renaissance the story inspired many masterpieces. Lorenzo Ghiberti executed a bas-relief of the aftermath of Flood for his famous baptistry doors in Florence, while in the same city Paolo Uccello provided his interpretation for the frescoes in the church of Santa Maria Novella. The most famous Renaissance version of the story, however, is the one Michelangelo painted for the ceiling of the Sistine Chapel in Rome. While the casket-like form of the ark floats serenely in the background, the image is dominated by the human drama of the sinners in the foreground, who are desperately trying to escape the rising waters. Nearby, in St Peter's, Raphael's fresco features

a white-bearded Noah supervising his three sons, who look as though they have taken on board the urgency of the situation and are in a hurry to finish the ark.

The German artist Hans Baldung took a more mischievous approach. Baldung, who distilled pictures from a disturbing mixture of witchcraft, death and eroticism, shows an ark looking for all the world like a locked casket with something precious inside. The water resembles bubbling green slime; naked sinners try to battle against it while one or two attempt to prise open the doors of the ark. Birds safely inside look down on them from little windows.

A 16th-century Dutch interpretation of the Deluge. Engraving by Cornelis Cort after Maarten van Heemskerck, 1585.

Many painters took on the story as a means of exploring their own styles and interests. In the sixteenth century the Venetian Jacopo Bassano used it to pursue his fascination: the accurate portrayal of animals. His work *The Animals Entering Noah's Ark* presents an energetic scene of cows, horses, sheep, chickens,

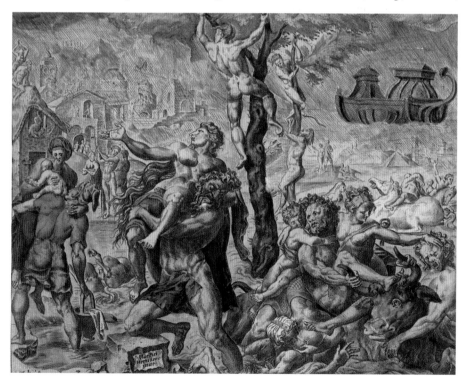

Depiction of the Flood
on the facade of
Bourges Cathedral,
France.

dogs and other domestic creatures milling around before they edge up the ramp into the vessel, which appears only in the corner of the picture. He took a second bite at the animal theme with another work showing them back on dry land after the flood.

Painting a little later, the Flemish master Jan Breughel the Elder was also intrigued by animals and the cataloguing of species. He includes in the same scene more exotic beasts, such as lions, tigers, parrots, camels and elephants, embarking under a brilliant blue sky. It is a colourful, rather uplifting spectacle depicting the glory of creation's variety in line with the wishes of his patron, Cardinal Federico Borromeo, a devotee of the Roman Catholic Counter-Reformation who wanted art to take a more

Michelangelo,
The Deluge, Sistine
Chapel, 1508–9.

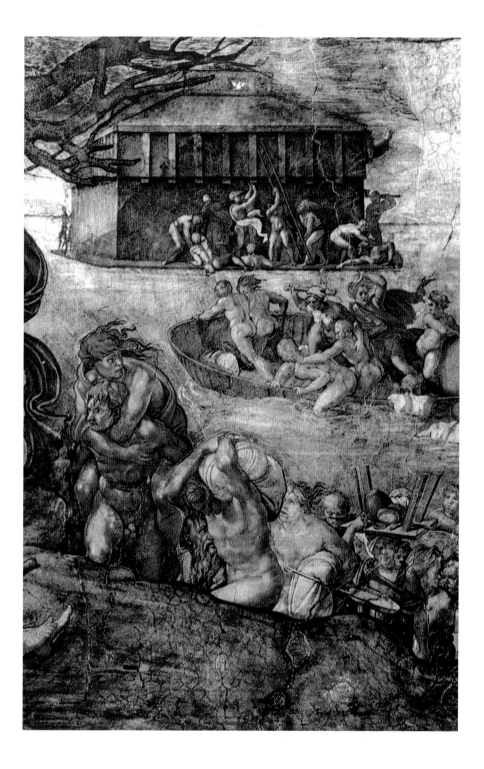

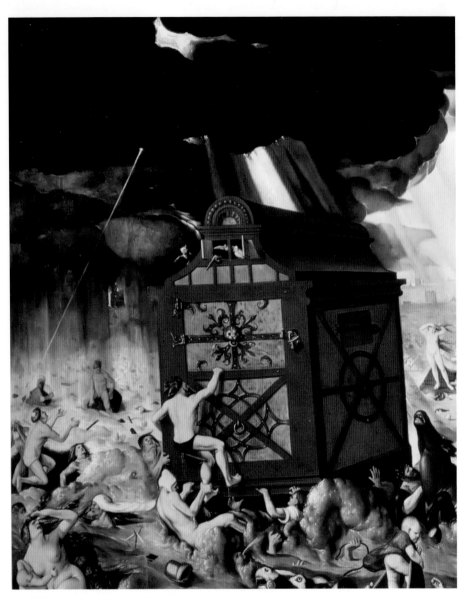

Hans Baldung, *The Deluge*, 1516.

Jacopo Bassano, *The Animals Entering Noah's Ark*, 1570s.

positive approach instead of terrifying worshippers by constantly dwelling on man's sins.

The preoccupation of the great seventeenth-century French painter Nicolas Poussin, on the other hand, was landscape. He featured the deluge as an image of winter in a series of paintings of the four seasons. Once again the ark appears as a small detail in the background, while lightning cleaves dark clouds in the sky, and in the middle distance a few humans try to escape in a boat. An old man clings to a floating piece of wood and a family try to save their baby, while a snake slithers ominously on a rock to the left of the picture. With its combination of ordered composition and the drama of threatening nature and terrified humans, it became a highly influential picture and was seen as one of the earliest examples of the 'horrific sublime' – an inspiration for later Romantic painters. Some observers maintained that the calmness of the painter's approach made the effect even more

sinister, and wondered if the small number of people featured in the picture represented the last of humanity, apart from Noah's charmed circle.

Jan Brueghel the Elder, *The Entry of the Animals into Noah's Ark*, 1613.

The subject was, of course, a godsend for the Romantic painters of the nineteenth century. Théodore Géricault offered a glowering black sky, teeming rain, capsized boats and humans fighting desperately for their lives. J.M.W. Turner also features glowering skies and a wrecked vessel, but his foreground is more heavily populated, with many dramatically lit half-naked figures in peril – or possibly already dead – through the awesome power of the Almighty. The great English painter also produced two much more abstract works: *Shade and Darkness – The Evening of the Deluge* and *Light and Colour – The Morning after the Deluge*. In the first we discern little detail apart from the black clouds and some horses in the foreground, while the second painting is dominated by a triumphant explosion of light at the centre –

Théodore Géricault,
Scene of the Deluge,
1818–20.

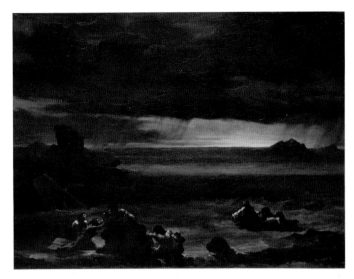

the manifestation of God's new covenant with man – to which the hinted-at human forms of the foreground very much play second fiddle. The Irish Romantic artist Francis Danby painted an epic scene dominated by furious waters which toss around tree trunks and hapless humans and animals as they try to cling to what had once perhaps been a mountain peak. Only the ark in the background, lit by moonlight, seems unshaken. Another

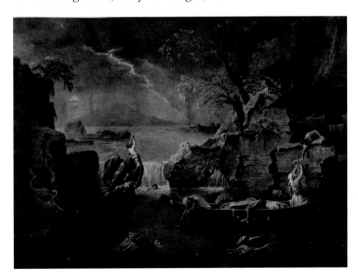

Nicolas Poussin, *Winter*,
or *The Flood*, 1660–04.

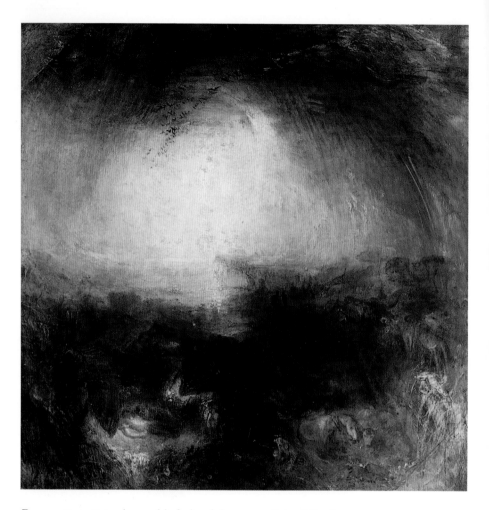

Romantic artist who tackled the deluge was John Martin, a 'phenomenally popular' portrayer of apocalyptic scenes who had also painted *The Destruction of Pharaoh's Host* and *The Destruction of Sodom and Gomorrah*.[1] Whether he was featuring the tiny boat at the centre of a fearful wave or the people being swept away in water turned blood-red, Martin went for a dramatic vortex-like composition as his way of demonstrating the fearful force of the flood.

The Pre-Raphaelite take on the ancient story was altogether prettier and more domestic. In *The Return of the Dove to the Ark*

J.M.W. Turner, *Shade and Darkness – The Evening of the Deluge*, 1843.

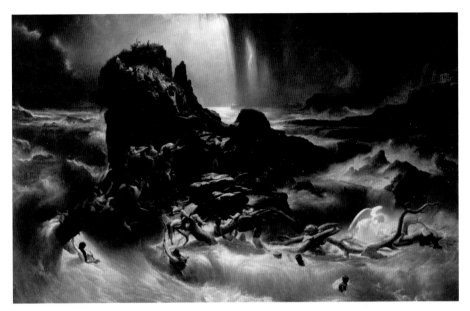

Francis Danby, *The Deluge*, c. 1840.

John Martin, *The Deluge*, 1834.

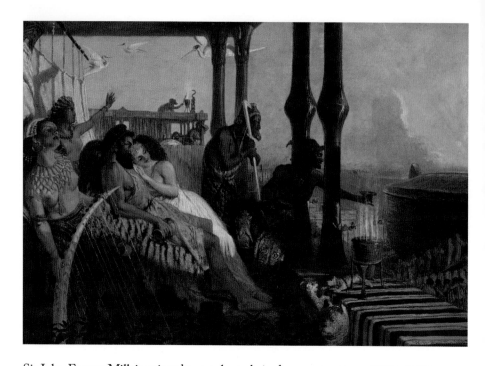

Sir John Everett Millais painted two auburn-haired young women in long gowns, Noah's daughters-in-law, gently tending to the exhausted dove which has completed its historic mission from the ark and returned with an olive branch. In contrast with the Impressionistic backgrounds, and indeed foregrounds, of Turner, every straw on the floor appears to have been individually drawn. In *The Eve of the Deluge*, Millais's contemporary, the Scottish painter William Bell Scott, muses on the depravity that provoked the flood, creating what could be a still from a Hollywood silent epic. On a sun-drenched terrace a couple of scantily clad beauties nestle against a potentate, surrounded by luxury on all sides, who has leopards at his feet, and looks down disdainfully on Noah building his ark.

William Bell Scott, *The Eve of the Deluge*, 1865.

Nor did modern artists lose interest in the subject. Marc Chagall produces a typically whimsical, swirling picture bathed in blue, featuring Noah and the dove, the ark, the animals and the wretched humans who will not be saved. Dalí's watercolour *Aquae diluvii super terram* (Flood Waters Over the Earth) was

John Everett Millais, *The Return of the Dove to the Ark*, 1851.

painted in the 1960s after a flash flood devastated Barcelona. The picture is dominated by a great black splodge at the centre, with the ark once again relegated to the periphery. In the twenty-first century the American photographer David LaChapelle has updated Scott's vision of antediluvian vainglory to include beautiful naked male and female models, the Las Vegas casino Caesar's Palace and fashion and fast-food logos, all falling victim to the rising waters.

Artists have also drawn inspiration from other ancient flood tales. The sixteenth-century Venetian master Jacopo Tintoretto painted a dramatic version of the episode from the myth of Deucalion, in which the hero and his wife pray for guidance from the goddess Themis on how they are to repopulate the world after the great deluge. We look up at them from beneath their feet, so the statue of the goddess towers above them against a sky full of ominous black clouds. The Italian Baroque painter Giulio Carpioni, working in the next century, chooses

Jacopo Tintoretto, *Deucalion and Pyrrha Praying Before the Statue of the Goddess Themis*, c. 1542.

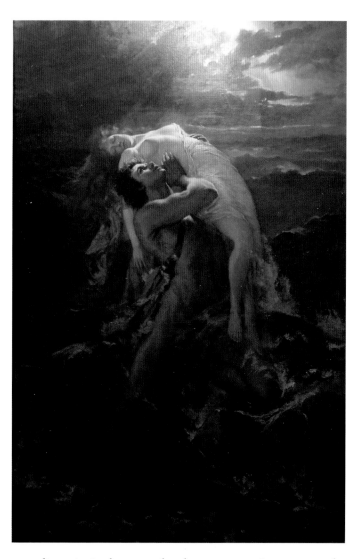

Paul Merwart (1855–
1902), *The Flood*, or
*Deucalion Holding Aloft
His Wife*.

an earlier point in the story when humans are trying to escape the
relentlessly rising waters. Three hundred years later the myth
was still providing inspiration for the French-Polish painter Paul
Merwart, but his approach is more personal, more Romantic,
as Deucalion heroically holds his beautiful, half-naked, uncon-
scious wife above waves that are forming jagged, angry peaks
like mountains. The Breton myth of the lost city of Ys provided
ideal material for Evariste Luminais, who specialized in histor-
ical subjects. His *Flight of King Gradlon* was a huge success when

it was first exhibited in Paris in 1884, and shows the moment when the king released his licentious daughter, Dahut, into the roaring waves.

In the New World, too, artists gave their take on old myths. The American Regionalist Thomas Hart Benton adapted the story of Achelous and Hercules – a Greek myth about a river god who normally provided life-giving irrigation but, during the flood season, took on the persona of a raging, destructive bull – for a mural at a Kansas City department store in 1947. In the centre of the picture Benton shows the moment when the animal is about to be tamed by having its horn torn off. On the right the horn is transformed into a cornucopia. The mural must have had particular resonance for local people, who often found themselves at the mercy of the unruly Missouri and Kansas rivers.

American artists also drew on myths from their own continent, with the contemporary sculptor Lyle E. Johnson creating a huge outdoor work based on the ancient Sioux legend in which a great flood covers the hunting grounds, drowning all the people except for one beautiful woman who is rescued by an eagle. The bird carries her to a cliff above the waves, where they mate, and she gives birth to twins who become the parents of a brave new tribe, the Sioux. The sculpture freezes the moment when the eagle scoops her into the sky.

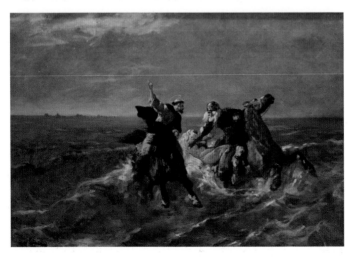

Evariste Vital Luminais,
Flight of King Gradlon,
1884.

A contemporary
woodcut of the great
Severn flood of 1607.

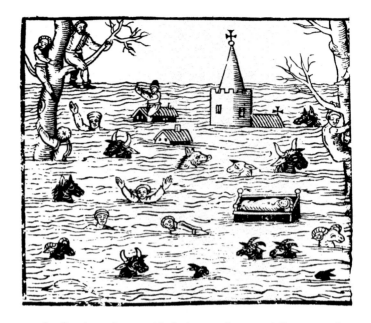

So flood myths provided plenty of material for artists, but until cameras were light enough to be moved into the sight of floods, painters and draughtsmen had another crucial job: documentation. An English woodcut showing men and animals fighting for their lives in waters that have risen to the roof of the local church was used to illustrate a contemporary pamphlet about the great Severn flood of 1607. In North America much early settlement happened beside the great rivers, and floods soon became a distressingly familiar experience. The pioneering land-scape painter Alvan Fisher was caught up in one of 'great fury' in 1837,[2] and depicted his family escaping on horseback from their inundated homestead while livestock tried to swim for safety, but it all looks rather serene and there is little feeling of terror. The function of documentation could easily slip into that of propaganda. When the Rhône burst its banks in 1856, flooding Avignon, Lyon, Tarascon and other towns, the French govern-ment of Napoleon III dispatched two artists, William-Adolphe Bouguereau and Hippolyte Lazerges, to record the event. Naturally they did so in a way that would show the emperor in a favourable light. Using highly formal compositions, both put him slap in the

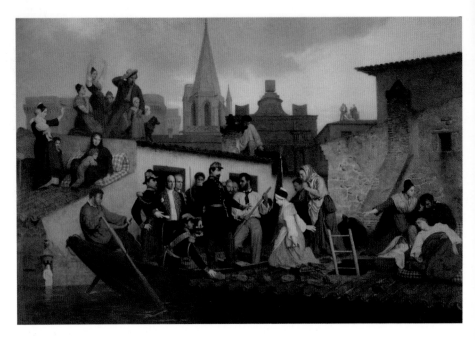

middle of the painting. Bouguereau has Napoleon arriving in a boat to talk to people taking refuge on a rooftop, while Lazerges shows him on horseback in a ruined quarter of Lyons.

William-Adolphe Bouguereau, *Napoleon III Visiting Flood Victims of Tarascon in June 1856.*

In 1940 a similar task came the way of the American Regionalist John Steuart Curry, a friend of Thomas Hart Benton, by which time a series of revolutions had engulfed art – Impressionism, Expressionism, Fauvism, Cubism and Surrealism, to mention just a few. *Life* magazine wanted Curry to depict a historical event, the great Mississippi flood of 1927, but his real task was propaganda. The magazine's publisher, Henry Luce, was strongly opposed to President Roosevelt's New Deal Democrats and wanted to give the Republicans a lift in the presidential election of 1940. The party's last president had been Herbert Hoover, who had been discredited by the Great Depression and ignominiously ejected from the White House in 1932, but Luce hoped that his reputation could be restored. As Secretary of Commerce, Hoover had been dispatched to superintend the relief effort in 1927 after what he described as the 'greatest disaster of peace times in our history', and the future president was reckoned to have had a good

flood. Curry was hired to create his historic epic as part of a series recording 'dramatic scenes in twentieth-century American history' by 'America's foremost contemporary artists'. When the Mississippi burst its banks the painter had been studying in Paris, but as a boy he had seen the region where he lived devastated by a flood of the Kansas River, and by the time he had been commissioned by *Life* he had already painted tornadoes, storms and droughts, as well as other floods. The Regionalists believed they should capture the everyday details of the lives of ordinary rural Americans with a strong sense of place, while drawing on the traditions of the Old Masters. From this mixed parentage *Hoover and the Flood* emerges in subdued browns. At the centre is not Hoover but a bearded black elder who is lifting his hands to the heavens, a gesture echoed by a black woman in a barge. The refugees in the picture are mainly African American, the rescuers mainly white. To the left the swollen river surges, threatening to snatch cattle and horses from the levee as it topples a telegraph poll and sweeps a house along. The paraphernalia of rescue is everywhere – sailors punting the barge, a doctor and nurse inoculating a child outside a Red Cross tent, a steamboat approaching from the distance and a newsreel camera recording the scene. Between the elder with raised arms and the right edge of the painting standing a little higher than anyone else is Herbert Hoover, smartly dressed in a suit and hat and calmly surveying the scene, flanked by an army officer and another man in a suit. A contemporary account speaks of him dispensing 'wise, quick, terse directions which were bringing order out of chaos'.[3]

Curry's friend Benton used art as propaganda in a different way. When the Mississippi flooded again in 1951 along with the Kansas River, killing seventeen people and driving half a million from their homes, he painted *Flood Disaster*. With a tense, angular composition reminiscent of the work of the German Expressionists, this painting shows wrecked houses and anguished inhabitants along with mangled possessions, such as a truck and a washing machine. Benton sent a copy to each member of Congress to try to persuade them to vote to give additional help to those caught up in the disaster. He failed.

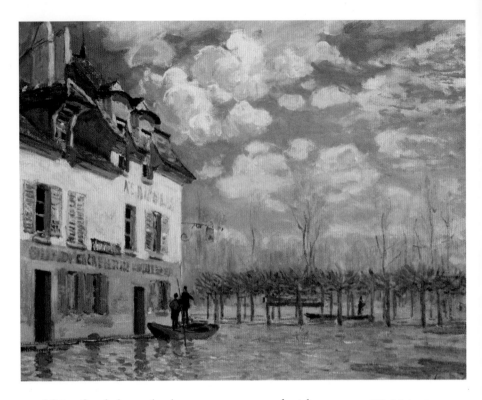

Major floods have also been commemorated with monu-
mental works, such as the four-panel portrayal of an inundation
of Hartford by the Connecticut River commissioned from Joseph
Ropes by the arms manufacturer Samuel Colt, and the mural of
the Chicago River flood of 1849 painted by Lawrence C. Earle
for the Central Trust Company of Illinois. But some American
artists tried to capture floods more generically: when the Ohio
River burst its banks in 1937, killing 385 people, the young
painter Mervin Jules depicted it as a swirling inundation free
of any victims, human or animal, but with Death racing along
the water on a great lump of wood torn from a tree like some
demented surfer of the Apocalypse.

In Europe the Impressionists too were attracted to floods,
though what intrigued them was how the changed landscape
provided a new visual laboratory in which to investigate the tran-
sient effects of light. Often this meant completing many versions

Alfred Sisley, *Boat in
the Flood at Port Marly*,
1876.

of the same view at different hours of the day. When Port-Marly on the Seine was inundated in the spring of 1876, Alfred Sisley painted it seven times. The water lapping at the side of buildings provided him with fragmenting reflections to explore. Claude Monet painted two canvases of swollen streams near his home at Giverny. In one, the light is a bright sunflower colour; in the other, cool lavender. Camille Pissarro's injunction was: 'Paint what you observe and feel. Paint generously and unhesitatingly, for it is best not to lose the first impression.'[4] To this end the Impressionists would drag their easels out into the open air. Pissarro himself painted the same flood in different lights at Eragny in 1893. The overwhelming effect created by these Impressionist paintings is that of tranquillity. They concentrate on the calm aftermath of the inundation; there are no humans or animals in distress or danger, no hint of the destructive power of the flood. The swollen waters are as serene as the Venetian lagoon.

Claude Monet, *Flood at Giverny*, 1896.

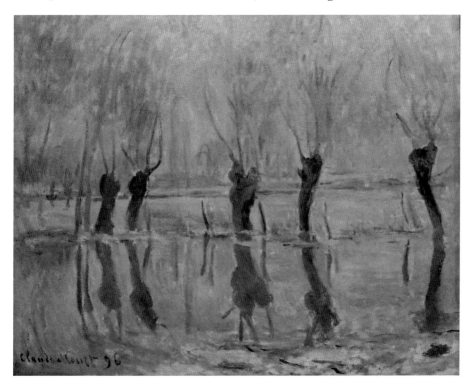

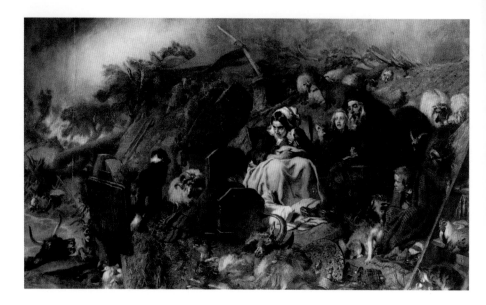

Other nineteenth-century European painters, though, were intrigued by the human drama of floods. The English Romantic Sir Edwin Landseer was best known for his pictures of animals, but a severe inundation in Scotland in 1829, known as the Muckle Spate, inspired him to produce the bleak *Flood in the Highlands*. The sky is gloomy and threatening, and on the turf roof of a farm, surrounded by sheep, dogs, chickens and a few possessions, a family cower in terror as the wind pins back the trees. Below, the rising water against which bigger animals are struggling appears almost as an incidental detail. The Anglo-Dutch painter Sir Lawrence Alma-Tadema was also inspired by a real flood when he painted *The Inundation of the Biesbosch in 1421*. A child sleeps serenely in its cradle beneath a dark sky, even though the waves are throwing it up and down, while a cat that is also on board looks as agitated as the child is calm. The only other object to be seen is a jug floating in the foreground. Legend has it that after the St Elizabeth's Flood of 1421 in the Netherlands a baby and a cat were found floating in a cradle; the cat was hopping from side to side to prevent it from capsizing.

The Pre-Raphaelite artist Millais used a strikingly similar composition in his *A Flood*, painted in 1870. The star of the

Sir Edwin Landseer, *Flood in the Highlands*, 1860.

Lawrence
Alma Tadema,
*The Inundation
of Biesbosch in
1421*, 1856.

Camille Pissarro, *View
of Bazincourt, Flood,
Morning Effect*, 1892.

work is a baby floating quietly in its cradle, seemingly fascinated by raindrops and a bird on the branch of a tree, while the waters, though much calmer than in Alma-Tadema's work, have partly submerged houses, trees and haystacks. Again a cat is riding on the crib, and appears more alarmed at their predicament than the sleeping baby, and, yes, there is also a jug floating in the waters, while in the distance there is a man punting energetically. Is he coming to their rescue or simply struggling to control the craft in the swirling eddies? Millais was supposed to have been inspired by the widely reported episode of a dam burst that took place a few miles from Sheffield in 1864 and which caused the deaths of 270 people. A number of newspapers reported the story of a baby being washed out of a house while still in its cradle. The picture, though perhaps too sentimental for some modern tastes, enjoyed great success at the time. The Swedish artist Carl Fredrik Kiörboe skipped the human element altogether and depicted a family of dogs trying to escape a flood on a floating chest. A bitch howls her anguish while a puppy shelters beneath her body. Another puppy is desperately trying to climb aboard while a third is still some way off in the choppy waters.

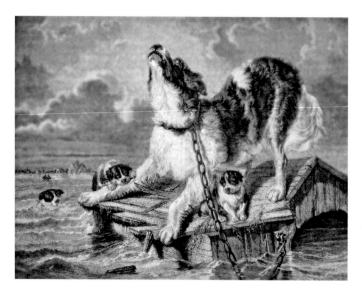

After *Flood* by Carl Fredrik Kiörboe, illustration published in *Magasin Pittoresque*, Paris, 1850.

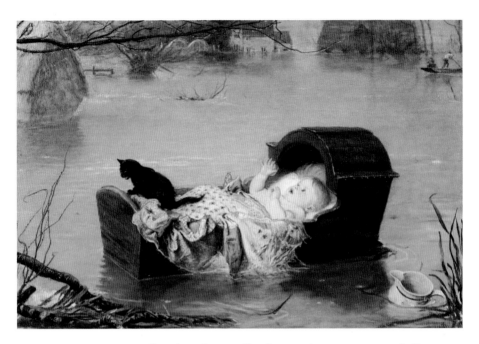

John Everett Millais,
A Flood, 1870.

In other pictures, floods sometimes seem to symbolize some wider ordeal faced by humanity. The American avant-garde painter Arthur B. Davies often tackled mythological subjects, and his work *The Flood* from 1903 was seen by some as a metaphor for humankind's confrontation with the daunting challenges of the dawning twentieth century. Two naked but anonymous women appear in the bottom-left foreground as a dreamlike, generic river surges behind them and trees bend in the wind. Or perhaps it is a comment on humanity's constant weakness against the elements; or a response to that year's flash flood that drowned nearly 250 people in Heppner, Oregon; or maybe all three. Similarly, Jon Corbino's energetic canvasses from the late 1930s, *Flood* and *Flood Refugees*, which depict the heroic determination of people trying to escape the Ohio flood of 1937, are sometimes considered as symbols of the USA's struggle against the Great Depression.

By the time these pictures were painted, the twentieth century had spawned a whole new art form – cinema. One of the first floods to capture film-makers' imaginations was the one that

struck Johnstown, Pennsylvania, on 31 May 1889. After months of heavy rain, what was then the biggest earth dam in the world at the South Fork Fishing and Hunting Club gave way, releasing 4 billion gallons of water to hurtle down the valley towards Johnstown. It devastated the town, killing at least 2,200 people. The disaster inspired an epic silent film, *The Johnstown Flood*, made in 1926, which wove a love story into the catastrophe and provided the first major role for the Oscar-winning actress Janet Gaynor. More bizarrely, the flood also became the subject of an episode of the *Mighty Mouse* cartoon series made in 1946. The audience is told that the Weather Bureau in Washington, DC, is supposed to have the most advanced forecasting instruments in the world, but that they are actually surpassed by the feet of an old mouse named Joe. When rain is threatening, his corns and bunions play him up dreadfully. On 30 May 1889, says the narrator, everything was calm in the little mouse village near Johnstown, with all the inhabitants settling down to sleep, but Joe could get no rest because his bunions were throbbing so badly. The cartoon shows clouds gathering and lightning crackling across the sky; rain comes down in buckets, then like cats and dogs. In reality, when the dam began to give way at Johnstown,

Arthur B. Davies,
The Flood, c. 1903.

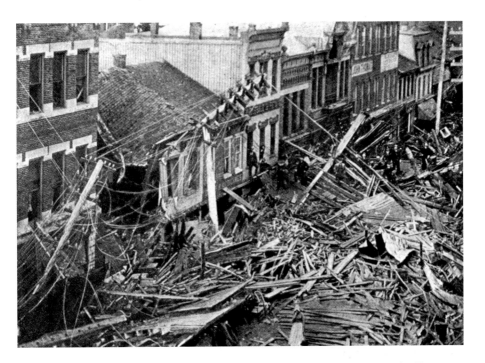

Main Street, Johnstown, Pennsylvania, after the flood of 1889.

the resident engineer leapt on his horse and galloped off to warn as many people as he could. In the cartoon Joe does the same, telling all the other mice to run for their lives, but up the valley the dam bulges and breaks, and many have to make desperate escape attempts in improvised vessels such as baths or upturned umbrellas. At this point, mercifully, news of the disaster reaches Mighty Mouse, who flies in like Superman and, to the cheers of all mousekind, pushes the flood back, washing swept-away houses back into place. Finally he walls the waters up again behind the dam, which looks suspiciously like stone or concrete rather than earth; but never mind.

Cinematic floods really came into their own in another genre – the disaster movie. One of the earliest examples is the American picture *Deluge* from 1933. It opens with scientists showing understandable alarm about a series of catastrophes that are engulfing humanity. The latest of these is a tsunami that is heading towards New York City. A radio announcer delivers the bad news, then the studio starts shaking and the floor and ceiling cave in. Skyscrapers

Poster for film, *Deluge*, 1933.

begin to collapse and people run for their lives. Some are buried in the rubble. Next, a huge wave crashes against the shore. On Liberty Island it reaches halfway up the famous statue. A liner is washed in from the sea, and those buildings still standing crumble one by one into the turbulent waters. As the scene fades, only the Statue of Liberty still stands defiant. Understandably, the flood sequence looks a bit amateurish to modern viewers, with the buildings obviously models, and even some contemporary critics were slightly sniffy about it. A reviewer at the *New York Herald Tribune* wrote: 'The collapse of the Manhattan skyline never quite succeeds in scaring you the way it should, but it is well enough depicted to be an entertaining screen stunt.'[5] Everyone seemed to agree that the rest of the film was pretty poor, with the *Herald Tribune* critic dismissing as 'feeble' the story of the survivors' ordeal that followed the disaster.

The flood sequence became famous, however, and was plundered for re-use in later films. It demonstrated its resonance 70 years later by influencing Roland Emmerich's highly successful *The Day After Tomorrow*, a disaster movie from 2004. The action opens with all kinds of strange weather events. While climatologist Jack Hall is warning the assembled good and great of the world about the fragility of the planet's ecosystem, it is snowing outside – in Delhi! At the same time in Tokyo, hailstones as big as grapefruit are felling passers-by in the street. Even so the politicians are unconvinced, with the u.s. vice-president emerging as top climate-change denier as he tells Hall that the enormous costs of fighting global warming would be unsustainable at a time when the world's economy is so fragile. When Hall argues with him, the vice-president gets his own back by cutting the National Oceanic and Atmospheric Administration's budget. Flocks of birds begin to desert New York City and Los Angeles is devastated by tornadoes, while Europe is battered by fierce storms and the temperature in Scotland dips to −150°F. This is obviously rather more exciting than the real progress of climate change, which in a disaster movie would be a bit like watching paint dry. Instead the film relies on a scientific scenario involving the melting of huge amounts of polar ice, which brings dramatic falls in ocean

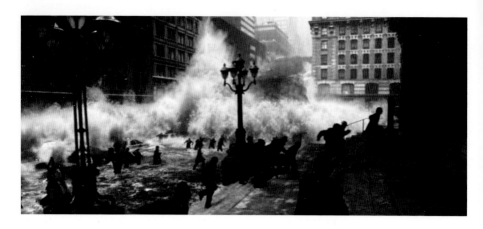

The Day After Tomorrow (2004). The flood hits New York City.

temperatures and changes the balance between fresh and salt water. This fatally disrupts the global currents that drag warm water up from the tropics to the northern hemisphere, making large parts of it too cold for humans. Even prophet-of-doom Jack Hall is taken aback by the speed at which it all happens. He thought it would take hundreds of years, not a few days! After the birds depart, New York suffers three days of heavy rain. Soon the streets are waist-deep in water. Then suddenly we see the Statue of Liberty submerged to her chest but still resolutely holding up her light as the thunder crashes around her. Shortly afterwards a wall of water half a dozen storeys high sweeps across Manhattan, washing away everything in its path and cutting down people who try to flee. There being no tsunami in *The Day After Tomorrow*, more buildings are left standing than in *Deluge*, and some survivors take refuge in the city's great public library while a huge ghost ship sails along Fifth Avenue. Flooding is followed by snow as the USA becomes a frigid zone. In a nice twist, Americans start trying to cross illegally into Mexico, and most surviving citizens of rich nations become refugees in Third World countries.

Some environmentalists thought the film did a useful job in drawing attention to the perils of global warming, but not many critics saw it as a landmark in cinematic art. The *Chicago Sun-Times* reviewer Roger Ebert opined: 'Yes, the movie is profoundly silly. What surprised me is that it's also very scary. The special effects are on such an awesome scale that the movie works despite

its cornball plotting.'[6] Others were less kind. *Rolling Stone* declared
that 'the only truly scary thing about this doomsday popcorn flick
is the monumental ineptitude of the acting, writing and direct-
ing', while the *New Yorker* saw it as 'so dumb, ill-written, and
condescending' that it feared that it might actually make people
more resistant to warnings about climate change.[7]

In *The Day After Tomorrow* the flood is part of a many-
faceted catastrophe. In another disaster movie released three
years later, *Flood*, it plays the starring role. This time the setting
is Britain and the event is quite explicitly an aggravated re-run
of the great North Sea coastal surge of 1953 in which heavy
rain combined lethally with a very high tide. The first inkling
of impending disaster comes in the north of Scotland, where a
50-foot wave crashes on to the town of Wick, drowning more
than twenty people. The deputy prime minister gives Met Office
forecasters a hard time for their failure to warn him of what was
coming. (The prime minister is away at a conference.) The chief
forecaster says that weather predictions are not an exact science,
but adds that he now feels sure the storm is going to head out
to sea. Professor Leonard Morrison's computer says different.
With a storm surge amplifying the highest tide of the year, it
predicts that the whole of England's east coast is under threat
and that the Thames Barrier will not be able to cope. Morrison
is straight out of the Jack Hall mould – a stubbornly dissident
scientist. When the flood barrier was built he had been a voice
in the wilderness, saying it would not be up to the job. His
obsessive refusal to be shaken from this view has severely blighted
his career.

Embarrassingly, following the Met Office's initial reassur-
ances, the deputy prime minister had gone on television to inform
the nation that the worst was over. Now the weathermen are
back, knocking on his door to tell him the storm has changed
direction and is heading back towards England. As the govern-
ment's emergency committee, COBRA, agonizes over what to do,
like a ghost at the feast, Morrison is summoned up via video-link
to deliver a sombre warning that the Docklands Light Railway,
68 underground stations, lots of museums and even Whitehall

itself are now under threat, not to mention 1.5 million people who live and work in the danger zone. And, says the professor, they have just three hours to get everyone out. The deputy prime minister quickly orders a mass evacuation, the flood barrier is closed and the police have to try to extricate people from the gridlocked streets, urging everyone to move to higher ground. As Morrison forecast, the Thames Barrier is overwhelmed, and the Royal Family has to be evacuated to Balmoral, while the Metropolitan Police Commissioner demands that the emergency services concentrate on saving the people of southwest London, who have the best chance of survival, even though that means abandoning those in the southeast of the city to their fate. As water surges around the Houses of Parliament, we learn that more than 200,000 people are missing.

At last the storm begins to abate, but too late to save Britain from one of the worst natural disasters in history. Overcome by remorse at his failure, the Met Office's chief forecaster kills himself, while the deputy prime minister goes on television to say that although it has never seen casualties like this before, London will survive. Morrison is still worried, though, and declares that the Thames Barrier must now be opened to let the water flow out. With all the controls underwater, this will have to be done

London under water in *The Flood* (2007).

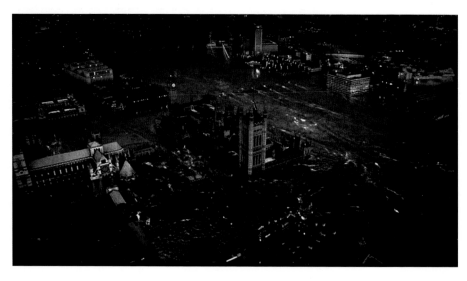

manually – a suicide mission that the professor himself carries out. He dies but thousands of Londoners are saved. *Flood* fared no better with the critics than *The Day After Tomorrow*. The idiosyncratic *Guardian* critic Nancy Banks-Smith dismissed it as 'tosh'.[8]

In another flood disaster movie, *Waterworld* (1995), set some centuries in the future, the deluge happened long before the action of the film. And what a deluge it was! 'Hundreds of years ago', says an eccentric inventor named Gregor, the ancients did 'something terrible'. The result was that the polar ice caps melted, and now there is not a speck of land to be seen. In what was at the time the most expensive film ever made, the hero, played by Kevin Costner, dashes around on his trimaran, which has huge sails that can be unfurled at the flick of a switch. Known only as 'the Mariner', this lone yachtsman may look like a man, or even a film star, but he has evolved gills behind his ears and webbed feet. The movie is packed with Heath Robinson-type devices, one of which turns the Mariner's urine into drinking water, and the dystopia in which he tries to survive is as bloodily lawless as the one depicted in the closing stages of Stephen Baxter's disaster novel *Flood*. When the Mariner turns up at an 'atoll', a down-at-heel, floating, walled village, to sell a priceless 3.2 kg of 'pure dirt', the locals go wild and open their wallets, but as he is about to leave they grab him and decide to 'recycle' him in some unspeakable yellowy-brown slime. In the nick of time a flotilla of pirates appear, fly over the walls on their jetskis and generally shoot the place up. During the resulting mayhem a woman named Helen rescues the Mariner from the lethal liquid on condition that he takes her with him, together with her adopted daughter, the feisty Enola, who has a mysterious diagram tattooed on her back. After much derring-do, they escape and sail off. At first the Mariner is not very chivalrous to his female guests, at one point throwing Enola overboard because they do not have enough drinking water, but gradually he warms to them. Meanwhile the pirates' leader, the Deacon – played with grotesque gusto by Dennis Hopper – is very keen indeed to get his hands on Enola because he believes the diagram on her back shows

the way to 'Dry Land', somewhere he has been promising to take his followers for a very long time – followers who are now running out of patience.

Helen also wants to see 'Dry Land', and one day the Mariner says that he will take her. He puts her in a diving bell and they descend to a landscape of wrecked skyscrapers, but when they return to the surface, the pirates are attacking the trimaran and they have to dive again, this time without the diving bell. Thanks to his gills, the Mariner is able to 'breathe for both of them', which involves giving Helen mouth-to-mouth suscitation, and at last, deep beneath the waves, the fires of love are kindled. By the time they emerge from the depths, though, the Mariner's trimaran is just a smoking wreck, and things look pretty bleak until the inventor Gregor appears in a weird-looking balloon and winches them up. After a killing spree of epic proportions they manage to escape the clutches of the pirates and sink the rotting hulk of a flagship from which they have been terrorizing the ocean. As the vessel is going down, her name is revealed: *Exxon Valdez*. The ingenious Gregor then deciphers the map on Enola's back, and flies them to a different Dry Land. This last remaining corner of earth is not the inhospitable tip of a mountain, as in Baxter's novel, but a lush, green, sunny land flowing with fresh water. Soon, though, the Mariner becomes unhappy. Enola tries to persuade him to stay, saying they are all suffering from land-sickness, but the hero's malaise runs deeper. He has evolved into a creature no longer suited to living on terra firma, so he builds a boat and leaves.

Waterworld did not do much for the critics either. The *New York Times* reviewer considered it 'crude', adding, 'It lacks the coherent fantasy of truly enveloping science fiction, preferring to concentrate on flashy, isolated stunts that say more about expense than expertise.'[9]

But not all modern film directors have been concerned with the fantastic, apocalyptic flood. *The Impossible*, released in 2012, is a straightforward human drama about a family of tourists caught up in the Boxing Day Tsunami of 2004 on Khao Lak beach in Thailand. It is based on a true story, but the (Spanish)

A live show based on the 'atoll' sequence from *Waterworld* at Universal Studios, Hollywood.

director turned the real-life Spanish family of a husband and wife and three sons at the centre of the movie into a British family. The tsunami scenes, filmed in a tank the size of a football pitch, graphically convey the dangers, not just of drowning but of being battered, impaled or strangled by the junkyards of debris that the wave rushes along. The family is split up – the injured mother surviving with her eldest son, the father with the other two boys – each group believing that the others have died. As Thai villagers and medical staff battle against an ocean of troubles,

the five are eventually reunited. *The Impossible* achieved a generally favourable critical response as well as success at the box office. Few, though, would regard it as a milestone in cinematic history. In 2013 we are still waiting for a great flood movie.

5 Defence

Some of the most ambitious structures ever built by human beings have been created in the hope of preventing floods, but one of the first methods to be tried was rather different – human sacrifice. While the Zhou emperors ruled China in the first and second millennia before Christ, they would hold ceremonies at which young girls were hurled into the country's notoriously trouble-some rivers in the hope of calming them. The Japanese adopted a similar approach, but one intended victim proved uncooperative. According to a legend in the ancient Japanese *Nihongi* chronicles, the Northern River burst its banks in two places in AD 323. A river god appeared to the emperor in a dream, demanding that two men be consigned to its waters as a sacrifice. The first plunged in and drowned, but the second, who was called Koromo-no-ko, flung two calabashes into the water, saying that if the god could prove his divinity by sinking them, he would gladly leap into the river. This seemed to anger the deity. Immediately a whirlwind started, but the 'calabashes, dancing on the waves, would not sink, and floated away over the wide waters'.[1] So Koromo-no-ko was saved, and, according to the *Nihongi*, the flood still subsided.

The sacrificial method of flood prevention was not confined to Asia. Similar stories come from Brazil and from New Mexico. According to a legend of the Zuñi people, a great flood had driven them from their village in ancient times, and they had to seek refuge on high land. Still the waters rose, so they took a youth and a maiden, the children of priests, dressed them in the finest robes and flung them into the waters. At once they receded.

The ancients also used other methods more familiar to us today, such as dams – barriers across rivers – which were built at least as early as the third millennium BC. Often they were made from earth. One of the first stone dams was the Sadd el-Kafara, constructed by the ancient Egyptians across the Wadi Al-Garawi about 19 miles (30 km) south of Cairo around 2600 BC. The outside of the dam was faced with limestone blocks, while the core was filled with rubble and gravel – 3.5 million cubic feet (100,000 cubic m) of it, according to the German archaeologist who discovered its remains in 1885. It was designed to be nearly 50 feet high (15 m) across a valley about 100 yards (90 m) wide, but after work had been going on for a decade or more it was swept away by one of the very floods it was meant to prevent.

To the east, the people of ancient Mesopotamia had to deal with the constant threat of flooding from the Tigris and the Euphrates. The land that spawned the myth of Gilgamesh tried a number of approaches, such as draining off surplus water through canals, which the people of every town and village were then ordered to keep clear of silt. But still the rivers flooded, so around 2000 BC, between Samarra and Baghdad, they constructed a barrier across the Tigris, probably from earth and wood. It was known as 'Nimrod's Dam' after the legendary king who built the Tower of Babel. Nearly four millennia later, the nineteenth-century archaeologist Sir Austen Henry Layard told of being on the river when 'its waters, swollen by the melting of the snows on the Armenian hills, were broken into a thousand foaming whirlpools by an artificial barrier, built across the stream.' The Arab guiding the raft 'gave himself up to religious ejaculations as we approached this formidable cataract, over which we were carried with some violence'. Once they were safely past the danger, the boatman told the passengers that the unusual change in the normally quiet river was caused by the remains of 'a great dam which had been built by Nimrod'.[2]

These dams were hugely demanding undertakings for ancient societies, but technological advances later enabled humans to attempt even more ambitious projects. Arch dams, relatively thin structures which work best in narrow gaps where solid rocks

on either side provide natural support, date back to at least the fourteenth century, but by the twentieth century the wider use of concrete enabled them to be built on an enormous scale. The arch dam at Pacoima, near Los Angeles, was 385 feet (120 m) high. It took five years to build, and when it was finished in 1929 it was the tallest dam in the world, closing a 600-foot (180-m) gap across a valley and holding back enough water to create a lake 3.5 miles (5.5 km) long. As work progressed a contemporary magazine proclaimed that downstream communities such as Pacoima and Sylmar would be saved from floods, 'for the structure will impound the waters during thaws and rains, and release them when all danger is past'.[3] The rugged peaks surrounding the site made it a fiendishly difficult building project. Engineers had to build a special tramway up the side of a mountain to carry materials. The concrete was mixed at the top before being slid down chutes to the dam below. More than 200,000 tonnes would be needed, enough to pave 10 miles (17 km) of road. The structure

Pacoima Dam, Sylmar, Los Angeles County.

was just 8 feet (2.5 m) thick at the top, spreading to more than twelve times that at the base. The dam is only 20 miles from the San Andreas Fault, and there are another half-dozen significant faults nearby, but it proved its strength by surviving powerful earthquakes in 1971 and 1994.

Pacoima did not enjoy its status as the world's tallest dam for long. Even while it was being built, plans were afoot to create an even higher one on the Colorado River, which watered the desert farms of southern California and western Arizona but also sometimes flooded them, sweeping away crops and people. In 1922 the idea was mooted of a dam at Black Canyon on the border of Arizona and Nevada great enough to hold back the biggest flood ever recorded there, but it would not be until America was in the grip of the Great Depression eight years later that the dam would be started, providing thousands of welcome jobs. A new town, Boulder City, was founded to house the workers, while the biggest trucks ever built at that time carted away the tonnes of earth they dug out. The world's biggest cableway also had to be commissioned to lower hundreds of tonnes of concrete and steel from the upper workings to the foot of the dam, which would rise 730 feet (220 m) from the canyon bedrock, the height

Boulder City, Nevada, 1932.

View from above
Hoover Dam near
Boulder City, Nevada.

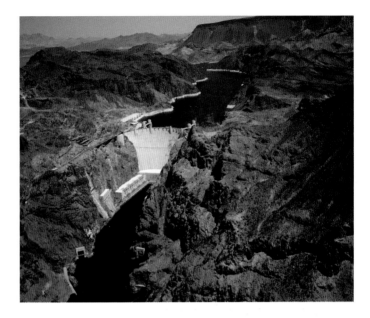

of a 60-storey skyscraper. Ninety-six men were killed as work proceeded at breakneck speed. Huge arc lights were deployed at night so that construction could go on around the clock, enabling the Boulder Dam to be finished more than two years ahead of schedule. By the time President Roosevelt dedicated it in 1935 it held another record – it was the costliest water project in human history, even though it came in under budget. The dam created one of the largest manmade lakes in the world, Lake Mead, which extended for 115 miles (185 km), and powered the biggest hydroelectric facility on earth, but its creators wanted to achieve something more than utility. An English architect, Gordon Kaufmann, had been hired to help design the administration building in Boulder City, but before long he was asked to chip in with his thoughts about the dam itself. Kaufmann sought to incorporate the flowing lines of the Art Deco style into the structure, while an artist named Allen True tried to give a similar feel to the interior of the powerhouse with mosaics based on Native American motifs. Two 30-foot-high (9-m) sculptures, the *Winged Figures of the Republic*, chosen through a national competition, were placed at the entrance. The sculptor, Oskar Hansen, said

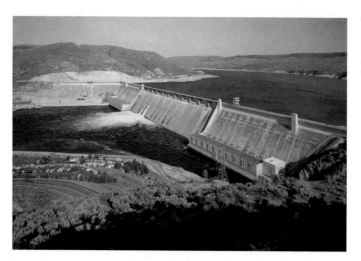

The Grand Coulee
Dam and Franklin
D. Roosevelt Lake,
Columbia River,
Washington.

they symbolized 'the immutable calm of intellectual resolution, and the enormous power of trained physical strength, equally enthroned in placid triumph of scientific achievement'.[4]

The dam became a major tourist attraction, drawing a million visitors a year, and was big enough to carry a major road, Interstate Highway U.S. 93. In 1947 the Boulder Dam was renamed the Hoover Dam after our old friend Herbert Hoover, who had been president when the project was given the green light.

Meanwhile, dams kept getting bigger. Within thirteen years the Hoover Dam would be overtaken as the biggest hydroelectric facility in the world by the Grand Coulee Dam on the Columbia River, which also played an important role in flood prevention. The 550-foot-high colossus had a crest that stretched for almost a mile. To the folk singer Woody Guthrie, it was simply 'the mightiest thing ever built by a man'.[5]

Over the decades that followed, though, dams would lose much of their heroic status. The New Melones Dam on the Stanislaus River near Jamestown, California, was designed as an earth and rock-fill structure 625 feet (190 m) high. Originally conceived to protect local communities from flooding, it acquired additional tasks, such as providing water for irrigation, industry and power generation, but its construction meant flooding the deepest limestone canyon in the western United States with the

loss of a popular stretch of whitewater rapids and important archaeological sites. Opponents fought the project for a decade, but work went ahead and the dam was finished in 1978. That did not end the opposition. As the u.s. Army Corps of Engineers began filling the huge artificial lake behind it, environmental activists camped on the land that would be lost, moving slowly upwards as the waters rose. Assiduously they drew the media's attention to the disappearance of farms, the old Gold Rush town of Melones and Native American rock carvings. One of the most determined even chained himself to rocks in the disappearing canyon. It all seemed to be to no avail. By 1982 the protestors had been defeated and the valley was flooded, but they had helped change the climate of public opinion, and sixteen years later, in 1998, the u.s. Secretary of the Interior, Bruce Babbitt, launched a campaign to start demolishing dams that damaged the environment. In the decade that followed more than 400 would be pulled down.

Even fiercer arguments were to erupt over China's Three Gorges Dam. Nearly 1.5 miles (2.5 km) long, and more than 600 feet (180 m) high, it would be the biggest in the world. As we have

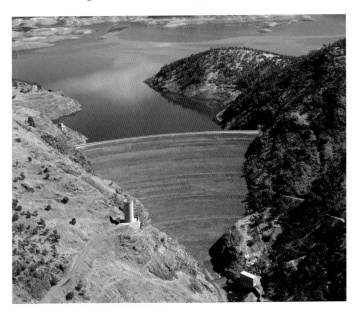

New Melones Dam
on the Stanislaus River,
California.

seen, for centuries the Yangtze River had flooded regularly, and Chinese leaders had discussed submerging the Qutang, Wu and Xiling gorges to create a vast reservoir 375 miles (600 km) long as early as the 1920s. This would protect millions of people living near the river as well as generating electrical power and allowing ocean-going ships to sail inland from Shanghai. But it was only in the 1950s, after the Communists had seized power, that serious planning began. Almost immediately there was fierce criticism of the project. Building the dam would mean moving at least 1.2 million people from their homes and drowning areas of great natural beauty, as well as 1,200 sites of archaeological and historical interest. The arguments went on for nearly 40 years, and even when the proposal finally came before the National People's Congress in 1992, one-third of this normally compliant body refused to support it in an unprecedented gesture of defiance. Protests spread beyond the borders of China and the World Bank refused to provide money for the project. It continued, though, and in 1997 work began in earnest, with the Yangtze being blocked and diverted. Six years later the reservoir began to fill, and the main wall of the dam was finished in 2006.

The origin of the dyke – or levee, as it is called in the United States – is also lost in the mists of time. These barriers of earth have been built along the banks of rivers to try to prevent flooding for thousands of years, and are among the first major civil engineering projects ever undertaken by man. Some of the earliest were erected from about 2500 BC in the Indus Valley around Harappa and Mohenjo Daro in what is now Pakistan, while the ancient Egyptians built them for more than 600 miles (965 km) along the Nile from Aswan to the Mediterranean. Some historians believe that the coordinated effort needed to complete works as ambitious as these stimulated the development of unified governments and organized societies in places like Egypt, while in China a project to build dykes was said to have led to the foundation of an imperial dynasty. According to an ancient Chinese chronicle, during the third millennium before Christ, the emperor Yan had grown tired of the constant floods of the Yellow River, complaining that its waters 'envelop the mountains and rise higher than the hills, and

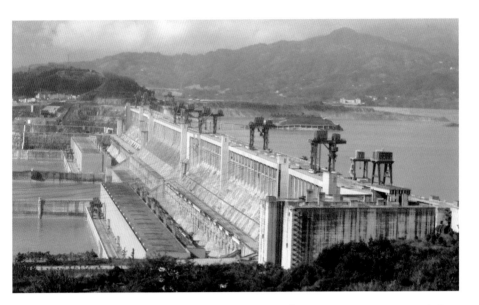

The Three Gorges Dam
on the Yangtze River,
China.

they threaten the very heavens'.[6] So he hired a man named Gun
to build earthen dykes far and wide to try to tame it. For nine years
Gun stuck to his task, but it was no good. The dykes kept giving
way and floods covered the land. For his failure the dyke builder
was imprisoned and, some say, executed. However, when a new
emperor, Shun, took over in 2286 BC, he hired Gun's son Yu to
complete the task that had defeated his father. Yu decided that
Gun had taken the wrong approach. Inspired, it is said, by the
many lines on a turtle's shell, he concentrated on dredging exist-
ing channels and digging new canals to drain away the flood-
waters instead of just building dykes. At one point where he
thought a mountain was making the Yellow River's channel
dangerously narrow, he even drafted in an army of workers to
cut a gorge that became known as 'Yu's doorway'. The engineer
had been married for only four days when he took on the job,
and for eight years he fought the river, never once stopping to see
his wife. Several times he passed his own front door. On the first
occasion he heard her in labour and on the second he heard his
son crying, but each time Yu told himself that countless people
were still being driven from their homes by floods and that he had
no time to interrupt his work. For his untiring efforts he became

known as Yu the Great, and Shun was
so impressed by his dedication that he
insisted Yu should succeed him instead
of his own son. The engineer became
the founder of China's first real dynasty,
the Xia, which would endure for more
than 400 years. For all that, Yu had
won a battle against the Yellow River,
not the war, and as we saw in chapter
Two, it would burst its banks to devas-
tating effect so often that it was dubbed
'China's Sorrow'. Indeed, in 1955, more
than 4,000 years after Yu's original efforts,
the Chinese government had to embark
on a 50-year programme to repair and
reinforce the dykes and build new flood
defences.

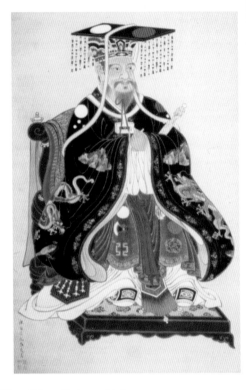

 River dykes may seem more pro-
saic than great dams but they are often
hugely ambitious undertakings. In
China a campaign began in 2010 to
obtain World Heritage status for the Yellow River Dyke, which
once extended for nearly 4,400 miles (7,080 km). Some said
that it was an even more deserving case than the Great Wall of
China, arguing that it demanded superior technology and that
its construction consumed enough effort to build thirteen Great
Walls. In modern times too human beings have constructed dykes
on a prodigious scale. Soon after New Orleans was founded in
1718, French settlers began raising levees beside the Mississippi
to try to prevent the constant flooding that was a curse of the
new settlement. By 1735 they were about 3 feet (90 cm) high
and extended more than 40 miles (65 km) along each bank on
either side of the city. Eventually they would run from Cape
Girardeau in Missouri to the Mississippi Delta in one of the
biggest networks in the world, comprising about 3,500 miles of
embankments with an average height of 24 feet, but sometimes
reaching twice that.

The Chinese emperor
Yu the Great, founder
of the Xia dynasty.

The Yellow River at Luoyang, China.

Building flood defences is a daunting enough task, but maintaining them can be even more difficult. Back in 629, after the Tigris and Euphrates both burst their banks, a local ruler tried to get better service from the workers responsible for upkeep of the dykes by having 40 of them crucified, and, as we have seen, poor maintenance of embankments was one of the main reasons for the disastrous Yellow River flood of 1931. Unfortunately the work tends to get more and more difficult over the years as the silt carried by rivers such as the Yellow River and the Mississippi keeps raising their beds so they are higher than the adjoining land the levees are designed to protect. In some places the bed of the Yellow River is as much as 60 feet (18 m) higher than the surrounding plain, and in New Orleans it is eerie to walk along streets close to the Mississippi and realize that its waters are above you, constrained for the moment, you hope, within its embankments. Indeed, one-third of the city sits below sea level.

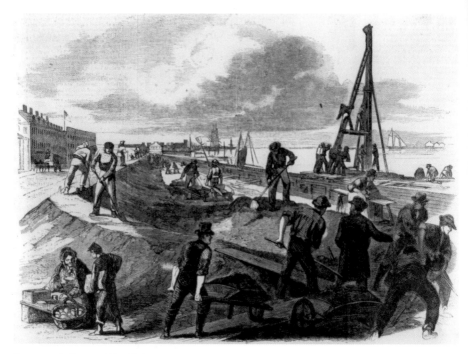

Repairing the levees at New Orleans, 1863.

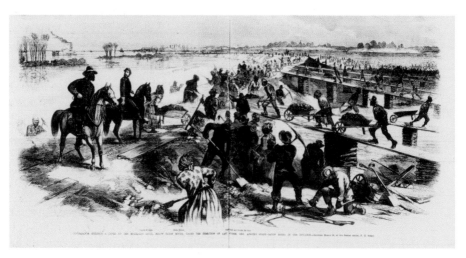

Building a levee on the Mississippi below Baton Rouge, 1863.

In Louisiana the task of making sure that the river defences were kept up to scratch was at first assigned to landowners. If they failed, the sanction was not execution but forfeiture of their estates to the French Crown. On this occasion, though, private enterprise failed, and the Mississippi frequently broke through weak points in the dykes, known as 'crevasses'. There was a whole series of such failures, including the Macarty Crevasse of 1816, which caused much loss of life before a vessel was sunk to seal the gap. Eventually the levees were entrusted to the u.s. Army Corps of Engineers. The city also had to be protected by drainage canals. Ten thousand Irish immigrants are said to have died from yellow fever while digging the New Basin Canal in the 1830s.

By the mid-nineteenth century, though, questioning voices began to be raised. There was no doubt that levees represented a great engineering achievement, but were they really the best defence against flooding? After another serious inundation in 1849, an engineer named Charles Ellet Jr argued that they concentrated water that had previously spread out across miles and miles of flood plain into a small channel, causing it to flow higher and faster and making dangerous floods more likely. The government rejected his view and continued to extend the levees as more and more people settled close to the river. Following the great Mississippi flood of 1927, Congress authorized a massive programme of further defences – dams, more levees and strengthening of the river's banks as well as the creation of bypass floodways to allow excess water to escape into agricultural land. After Hurricane Betsy brought a flood that caused 58 deaths in Louisiana in 1965, there came another huge bill for additional levees and barriers around New Orleans, with Congress voting to spend $85 million.

Impressive though some river dykes might be, even more ambitious structures were needed when humanity took the fight to the waters, as it were, and started reclaiming land from the sea. According to an old saying, 'God created the earth, but the Dutch made Holland', and the Netherlands became the world leader in this field. The Dutch began building sea dykes as early as the first century AD, and in the millennia that followed they would wrest hundreds of square miles of land from the North Sea. It has been

estimated that a quarter of the country's arable land has been garnered in this way – sometimes as small patches of marsh, lake or bog; sometimes hundreds of square miles, as in the Zuiderzee project. By the end of the ninth century much of the coastline was already protected, but peat bog cultivation caused the land to sink. In 1250 the 78-mile-long (125-km) Westfriese Omringdijk had to be built to hold back the sea in North Holland. The need to ensure that all inhabitants of the region played their part in maintaining the dykes stimulated the appearance of the country's earliest democratic institutions – 'water boards' – which appeared as early as the thirteenth century in places such as the islands of Walcheren and Schouwen. They survive to this day. Meanwhile dyke technology continued to develop. By the fourteenth century and probably earlier, the Dutch were using seaweed to strengthen their dykes, just as the Chinese had for centuries reinforced their silt embankments along the Yellow River with great bales of sorghum. The Dutch favoured eelgrass, which they compacted into belts about 12 feet (3.5 m) high and 6 feet thick. These they put on the seaward side of their earthen dykes, fixing them down with rows of oak and pine beams. Then they protected the base of what became known as *wierdijken*, seaweed dams, with bundles

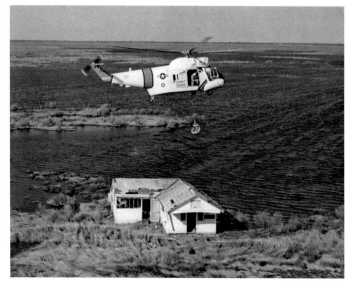

A u.s. Coast Guard Sikorsky HH-52A Seaguard helicopter rescues a man who rode out Hurricane Betsy in a house near a swamp west of Delacroix, Louisiana, 1965.

Water board crest,
Delft, Netherlands.

of brushwood. These dykes too needed constant maintenance, with the top layer of eelgrass having to be replaced every couple of years.

The fifteenth century saw more new technology with the introduction of the country's trademark windmills that powered pumps to keep reclaimed land dry, and the construction of bigger, stronger dykes, such as the Westkapelle and the Hondsbossche Zeewering, which still form the basis of some of today's sea defences. By now the Netherlands's expertise was known internationally, and when the people of Canvey Island in England wanted to erect sea walls in 1622 they brought in the Dutch. But in the 1730s more innovation was needed at home, as a pest called shipworm ate its way through the beams that compacted the seaweed on the *wierdijken* so they snapped like matchsticks. There was panic until two mayors of Bovenkarspel in North Holland came up with what became the new standard dyke – a sloping structure of earth and clay covered with stone.

The Dutch had been talking about damming the Zuiderzee, a shallow inlet separated from the North Sea by an arc of sandflats, as early as the seventeenth century, since people living around it suffered from constant floods. The last straw came in 1916 when a fierce storm combined with a high tide swept away dykes in

Windmill, Holland.

many places, and sixteen lives were lost on the island of Marken. A civil engineer turned politician named Cornelis Lely came up with a plan to build a 19-mile (30-km) barrier known as the Afsluitdijk, or 'enclosing dam', which would separate a new artificial lake, the IJsselmeer, from the North Sea. Made from a core of clay and boulders and faced with stone, it lay on mats of willow, with a road (widened in the 1970s to a motorway) running along the top. The dam took five years to build and was opened in 1932. Over the next half-century nearly half of the enclosed area was reclaimed, providing homes for about 400,000 people. In the 1930s building the dyke created jobs for the unemployed, while during the Second World War local men volunteered to work

on reclaiming the new polders behind it to avoid being sent to do forced labour in Germany. One of the new cities built on the reclaimed land was named Lelystad after the project's originator. While the reclamation work was going on, the Netherlands suffered the terrible shock of the 1953 floods, in which 400,000 acres were flooded and 1,800 people killed. The disaster stimulated one improvised defence technique in which life seemed to imitate the fictional story of the boy with his finger in the dyke. When a local mayor discovered a breach was opening in one of the dykes in South Holland, he requisitioned a grain barge and got two men to steer it into the gap, while hundreds of volunteers braved the flood to pile up sandbags next to the vessel, closing the hole completely and saving many lives. Today a monument stands at the site.

The storm surge barrier Oosterscheldekering, part of the Delta Project, which protects the Netherlands against flooding from the North Sea.

The Netherlands's response to the disaster was another massive sea defence project further south along the coast, where the estuaries of the Rhine, Maas and Scheldt rivers divide the country into a delta of islands such as Walcheren and Noord-Beveland. Known as the Delta Project, it involved joining them

up with ten dams and two bridges and took more than 30 years to complete. Perhaps the most innovative section was a 2-mile (3-km) barrier made up of more than 60 floodgates between massive concrete piers, the Oosterscheldekering, crossing the Eastern Schelde estuary. This allows water to flow in and out in normal conditions and is only closed in an emergency. The final piece of this giant jigsaw was the Maeslant barrier at the Hook of Holland, a massive steel floodgate where the Maas River meets the North Sea. The American Society of Civil Engineers declared the Zuiderzee and Delta projects one of the seven wonders of the modern world, commenting that 'this singularly unique, vast and complex system of dams, floodgates, storm surge barriers and other engineered works literally allows the Netherlands to exist.'[7] A quarter of the country, including Amsterdam and Rotterdam, lies below sea level, and without these sea defences its most densely populated areas would be submerged.

The floods of 1953 also prompted soul-searching in England, where more than 300 people had been drowned. London escaped the worst of it, though 1,000 people were forced from their homes, but the capital has had plenty of experience of finding itself underwater. One of the earliest recorded instances came in 1236, when the Palace of Westminster was inundated and lawyers had to get around the Great Hall in boats, and over the next seven centuries the city would suffer dozens of floods. One that caused especial alarm happened in 1928 when the embankment wall

The Afsluitdijk, Netherlands.

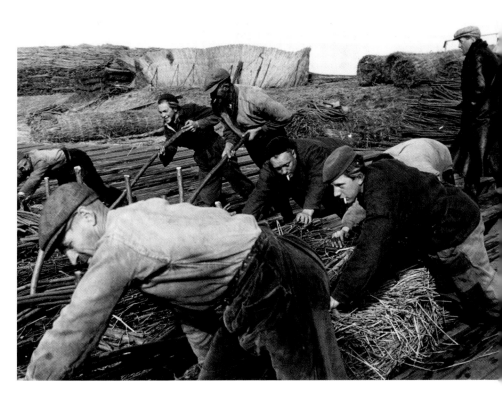

Reclamation of land in the Zuiderzee region, Netherlands, *c.* 1948–55.

between Lambeth and Vauxhall Bridges gave way in three places. At the Tate Gallery (now the Tate Britain), a night-watchman had to escape by swimming through flooded corridors, and along the length of the river fourteen people were drowned. A flood barrier for London had been talked about since the eighteenth century, but it was only after the Coronation-year flood that an official inquiry recommended that one should be built as quickly as possible. Even that did not settle the argument. Where should the barrier be? How could its design ensure that 1,000 vessels a week would be able to pass by it? And would it not be a terrible eyesore? On the other hand, if the worst came to the worst, a combination of wicked weather and a high tide could flood 45 square miles (115 square km) of London, threatening the homes of a million people and, of course, Whitehall and Westminster. The Isle of Dogs, which was then still a declining area of Docklands but was soon to be a major international business district, would

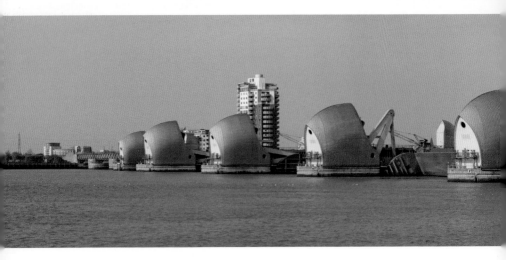

be flooded to a depth of 8 feet (2.5 m). Forty different ideas were examined, such as a giant portcullis that could be lowered to block the river and huge gates on rubber wheels that could be trundled out from dry docks in the banks and run into place along the bed of the Thames.

Thames Barrier.

Finally a design was chosen that was based on a row of seven piers – small islands often described as looking like miniature Sydney Opera Houses – that would be strung out across the river for 560 yards (510 m) between New Charlton on the south bank and Silvertown on the north. Work at last began on the foundations in 1974. Each pier is built of wood covered with a stainless-steel skin. They are 215 feet (65 m) long and stand 165 feet (50 m) high from their foundations. Between each pair is a gate. On either side of the Thames the gate closest to the bank is normally held in position above the river. When it needs to be closed it is simply lowered. River traffic cannot pass through these gates. The innovative ones sit between the piers in the middle of the river; these are known as 'rising sector gates'. The main navigation channels between them are 200 feet wide, as broad as the opening of Tower Bridge. Each rising sector gate is made of steel shaped like a quarter-moon with a straight edge, and when the barrier is open it lies flush with the riverbed in a scalloped concrete space, allowing the tide to ebb and flow naturally. They are more than 60 feet high and weigh more than 3,000 tonnes. Closing them takes about an hour and a half.

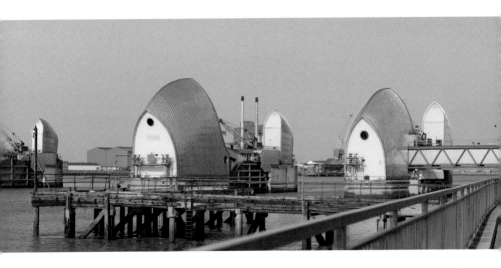

Hydraulic machinery swings each gate through 90 degrees until they present to the river a wall as high as a five-storey building.

The innovative design meant there were many challenges for the builders to overcome. Concrete bases had to be made in a dry dock on the north shore. Then the construction area was flooded and they were towed into position and sunk into dredged trenches. A labyrinth of shafts, tunnels and stairways had to be incorporated into the piers to allow access to machinery. To stop the barrier being pushed bodily upriver by the tide, the foundations were cut into virgin chalk nearly 50 feet (15 m) below the riverbed, but this was tougher and deeper than expected – sometimes too tough for the drills. Geological snags like these held up the project for nearly nine months. Then there were labour disputes and raging inflation so that, in the words of *The Times*, the price 'soared from the merely enormous to the truly colossal'.[8] Initially the barrier was supposed to cost £170 million, but that figure eventually grew to more than £430 million, making it one of Britain's costliest ever civil engineering projects. Another £250 million had to be spent on strengthening defences downriver to protect areas that would otherwise be flooded when the barrier is closed. The world's biggest movable barrier apart from the Oosterscheldekering, it finally opened in 1982, two years late. Up to November 2011, the Thames Barrier had had to be closed nearly 120 times to protect the capital, but there are fears that it may be fighting a losing battle. For thousands of years the

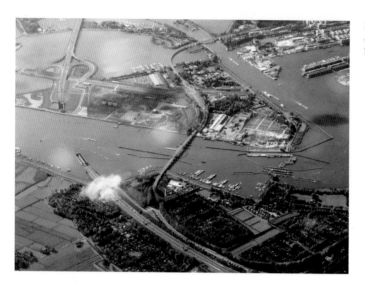

Zeeburgereiland. Much of the Netherlands lies below sea level.

southeast of England has been slowly dipping into the sea as Scotland recovers from being weighed down during the last ice age, and in London the effect is magnified by the city's buildings settling into the clay on which they were built, so that over a century, high tide in the Thames had risen by 2 feet (60 cm). These factors, combined with a global rise in sea levels, have led to warnings that by 2075 the barrier will not be big enough to protect the Londoners and the £80 billion worth of buildings and infrastructure that depend on it, and that a major new defence may be needed.

In the decades since the Thames Barrier opened, ever more ambitious flood defences have been appearing all over the world. In California, Britain, Germany and the Netherlands there have been experiments with 'smart' embankments fitted with electronic sensors that can raise the alarm if a stretch has grown weak and might be in danger of giving way. In countries such as Japan 'super - levees' were built that were about 30 times as wide as they were high, often with buildings and parks on top. But as humanity learned to build more and more sophisticated defences, unhappiness about the effect they were having on the environment grew, and uncertainty increased about their effectiveness, just as had happened with dams in the United States and China. As early as

the 1960s, murmurings were being heard in the Netherlands about the loss of historic landscapes and buildings as ever bigger dykes were built.

A *New York Times* writer noted that in many a picturesque Dutch village 'guarded by sea walls, it is possible to hear the waves crashing, see the seagulls circling and smell the salt air but never see the ocean'.[9] The village of Petten by the Hondsbossche Zeewering dyke about 30 miles (50 km) north of Amsterdam is one such. Between 1976 and 2001 the authorities doubled the size of its sea wall so that it was more than 40 feet (12 m) high and 150 feet (45 m) wide, but still local people wondered if it would be big enough, especially with the country's Delta Commission forecasting that sea levels could rise by 4 feet (1.2 m) by the end of the twenty-first century. As floods in 1993 and 1995 forced the evacuation of more than 250,000 people, the government set up an inquiry to examine whether there were other, gentler ways of preventing floods. It decided to spend up to $25 billion to improve existing defences, but also to surrender 220,000 acres by 2050 to the Rhine and Meuse rivers in a €2.3 billion project known as 'Room for the River' – meaning that many people would have to give up their homes on floodplains. A further 62,000 acres would be earmarked as pasture into which floodwaters could flow temporarily. Meanwhile, Rotterdam invested €100 million in developing innovative ways of containing floods, such as

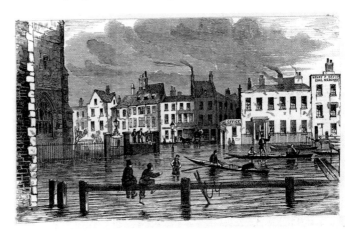

The Thames flooded at Lambeth Stairs, 1850.

creating 'water plazas' that served as playgrounds in normal conditions but could be used to hold water during spells of heavy rain before it was slowly released into the drainage system. Other measures included getting an Olympic rowing course to double as a water store, and putting a 2-million-gallon water tank in an underground car park. Arnoud Molenaar, manager of the city's climate change programme, said: 'We've always invested in prevention, wanting to keep the water out, but now we are trying to find solutions to live with the water. Keeping on with traditional techniques like raising the dykes is coming to an end because it's not possible to raise them higher and higher.'[10] An environmental engineer at the Massachusetts Institute of Technology, Rafael L. Bras, who has advised Venice on flood defence, echoed those thoughts: 'You'll never be able to control nature. The best way is to understand how nature works and make it work in our favour.'[11] After inundations in the Midwest in 1993, the U.S. Federal Government adopted the simple expedient of paying people to leave areas threatened by the waters. It bought 25,000 properties and converted thousands of acres to wetlands. When floods struck again in 1995 the wetlands soaked them up like a sponge and they were not nearly as damaging.

In the UK too the Environment Agency began looking for areas that could be used as floodplains. Sometimes they might

House on stilts in Na Khun Yai, Nakhon Phanom province, Thailand.

A Dutch home of the future? It floats and rotates to take advantage of solar energy.

be landscaped so they could hold even more water. After a flood at Lewisham in southeast London in 1968, for example, the River Quaggy had been confined in a concrete culvert, but in 1990 local residents opposed a plan to expand the defences. The authorities relented, released the river and moulded around it a floodplain, which was expected to be pressed into use every couple of years, though it was recognized that once in every 100 years on average, it might prove unable to contain the waters. The agency's head of flood policy conceded that some of the 'hard engineering' solutions of the past had been mistakes, and that a 'more natural approach' needed to be adopted.[12] One of the bonuses of the new philosophy was that it created better habitats for wildlife, and the Quaggy's floodplain quickly attracted Canada geese, ducks, moorhens and dragonflies.

Another novel approach to flood defence has been to change the design of houses. The Dutch came up with wooden dwellings in which the basement rests on a riverbed while the other two storeys sit above it. If the river rises the house floats up with it, and flexible pipes keep it connected to electricity and water supplies. Disastrous floods in 2011 also set the Thais thinking about floating homes. Inspired by traditional houses on stilts, a local architect started offering amphibious dwellings that had flotation

devices underneath, so they could be lifted on the waters when necessary, sliding up a pillar by which they would remain attached to the ground. His first client was a wealthy advertising executive who bought a 4,000-square-foot (370-square-metre) dwelling kept afloat by eight hollow pontoons on a lake formed by the Srinakarin Dam. The architect and his team then investigated whether they could provide floating homes at the village of Pa Mok on the Chao Phraya, which had been flooded nearly every year since 1942, though never as badly as in 2011. In addition to houses they proposed floating food shops and a village pavilion that could serve as a centre from which aid could be distributed in the event of another flood. They also worked on prototypes of an amphibious community for workers on one of the industrial estates that had been inundated. As we will see in the next chapter, though, flood defences of all sorts may soon be facing their sternest ever test.

6 Defeat?

It is one of the most famous images of the early twenty-first century. A woman who has just given birth in a tree, clinging to the branches above rising floodwaters, and then being winched up into a helicopter. The mother, Sofia Pedro, said that 'the worst floods in living memory' reached her home in Mozambique at three o'clock on a Sunday afternoon in February 2000.[1] The water moved remorselessly upwards until she realized, heavily pregnant though she was, that her only hope of safety was the tree. She had been there without food for three days when her labour pains started. Suddenly, a South African military helicopter appeared overhead. It flew off to pick up a doctor, who helped as she and her new daughter Rositha were winched into the aircraft, where he cut the umbilical cord. Meanwhile in the capital, Maputo, thousands were forced to flee. Then, to make things worse, a tropical storm hit the country's coast. By the time Sofia and Rositha were rescued perhaps 100,000 people had been evacuated from their homes. Before the waters subsided 800 people had been killed and more than 110,000 small farmers had lost their livelihoods in the worst flood the country had seen for 50 years.

In 2007 Mozambique would face another devastating flood, which would hit fourteen countries across the middle of the African continent from Senegal to Ethiopia. The United Nations reported that at least 250 people had been killed and more than 600,000 made homeless. Uganda saw its worst rains for 35 years, while the coordinator of Ghana's disaster management organization said that 'some villages and communities have now been

totally wiped off the map'.[2] Mozambique lost about 30 lives. The floods came back the following year. In an episode reminiscent of Sofia Pedro's story a 37-year-old woman gave birth to triplets on a flooded islet in the Zambezi River and then had to wait to be rescued by the emergency services. That year in Namibia more than 40 people died as rivers reached record levels, while a quarter of a million were cut off in the Owambo region and could be reached only by helicopter. Angola, Zambia, Zimbabwe and eight countries in West Africa were also inundated, while 100 people perished from cholera in Guinea-Bissau – a reminder that floods do not only cause death by drowning. The following year the melancholy pattern was repeated. This time Namibians faced a new danger as crocodiles and hippos swam through the flood-waters and attacked them. Angola and Zambia fell victim again, along with twelve countries in West Africa, and up to 320 people were killed. There were a similar number of victims in 2010 when Benin suffered its worst floods in nearly a century and the River Niger reached its highest level for 80 years. Floods devastated areas that had previously been thought invulnerable. A senior relief worker said: 'All the elders agree that they have never seen such flooding.'[3] Meanwhile in eastern Uganda the heavy rain unleashed a series of vicious landslides which killed another 300 people. One survivor said he was attending a church service when the building suddenly collapsed: 'Mud covered the whole place. Five people seated next to me died. I only survived because my head was above the mud.'[4]

And it was not just Africa. In August 2010 nearly 17 million Pakistanis were caught up in floods caused by the most torrential monsoon rains in 80 years. UN Under-Secretary-General for Humanitarian Affairs John Holmes described the disaster as 'one of the most challenging that any country has faced in recent years'.[5] The floods began in the mountains in the north of the country before surging south. One man from a village between Peshawar and Islamabad said there had been no warning: 'By the time I gathered up the children, the water was waist high.'[6] A villager living to the northeast of Peshawar recounted that when the floods came they moved the women and children to high ground, but

Sofia Pedro being
rescued from the
Mozambique flood
just after giving
birth, 2000.

three of his daughters stayed behind
to help the men pack up whatever
belongings they could carry. 'Within
minutes,' he said, 'the current got
too strong.'[7] As the waters rose to
head height two of his daughters,
aged sixteen and seventeen, were
swept away. Their bodies were found
three days later about 4 miles from
the village. A BBC correspondent fly-
ing over the stricken area described
brown water covering everything.
In some areas people could be seen
wading through it, chest-deep, while
in others only the tops of trees were
visible. A tourist from Britain was
travelling in a minibus in northern
Pakistan when it ran into a mudslide
in the darkness. 'Rain was still pour-
ing. Big rocks were blocking the
road.'[8] First they tried to climb over
the obstruction, then they attempted to clear the way, 'but rocks
were falling all around us. We couldn't get any further.' The floods
brought down power lines, uprooted communications towers
and washed away roads and 45 major bridges, as well as devas-
tating towns and villages, destroying more than 1 million homes.
In addition, around a fifth of the country's crop-growing land
was flooded.

Even when the floods receded there was little relief. Every -
where there was mud, often holding dead human bodies. A man
living in Charsadda complained that there was no food or water,
and that people were going down with diarrhoea and skin infec-
tions, but no one could leave because there was no transport. A
doctor from Swat said that he wanted to help people who were
ill but he had no medicines and no means of travelling. 'I'm
sitting in front of a pregnant lady who needs medical assistance
and there are no roads to take her to hospital.' He was afraid some

people had contracted cholera: 'There is no electricity, no drinking water. Nothing is working.' Another doctor in Peshawar said the price of essential goods had trebled. Many people faced destitution. A resident of a village northwest of Islamabad lamented: 'Everything has washed away – the trees, houses and our animals.' In his home, the mud was 4 feet (1.2 metres) deep. A man who had owned a house and a fabric shop found himself sharing a single room with 33 members of his extended family in a school building converted into a makeshift refuge, while a nearby Afghan refugee camp of 5,000 mud huts was just washed away.[9] Across Pakistan around 1,750 people were killed altogether, along with perhaps 1 million farm animals. Six months after the floods, 170,000 survivors were still in relief camps and many more were living in tents beside wrecked homes. Huge areas of land remained under contaminated water and nearly 2 million people were still dependent on the charity Oxfam. The total damage was estimated at up to £25 billion.

In the same year mudslides around Zhouqu in China killed more than 1,100 people, while across the country, flooding caused

u.s. Army Chinook helicopter evacuates people from Khyber Pakhtunkhwa, Pakistan, 4 August 2010.

tens of billions of pounds worth of damage, while in 2011 Pakistan was again struck by devastating monsoon floods, with 250 people killed and another 600,000 homes destroyed. Another 2 million people were estimated to have fallen ill from flood-related diseases. Many of those caught up in the new floods were still trying to rebuild their lives after the previous year's disaster, and when the prime minister visited Sindh province a group of women blocked the road to tell him that they had nothing to eat and their children were starving. In many parts of the world 2011 was a devastating year for floods, with Colombia ravaged by inundations and mudslides described by its president as 'the worst natural disaster that we can remember'.[10] The same description was given by Brazilians to the floods and mudslides that claimed more than 500 lives in their country. With three-quarters of the Australian state of Queensland hit by floodwaters, its prime minister declared it perhaps the worst natural disaster 'in the history of our nation'.[11] The United States, North and South Korea, the Philippines and China (again), where floods were said to be the worst in 50 years, were among other countries that suffered badly.

For the millions caught up in them these were horrifying experiences, but flooding is the disaster most likely to afflict humanity. So is there any evidence that it is getting worse? One

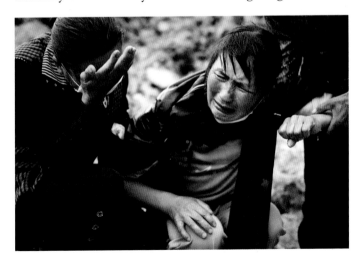

Relatives mourn victims of mudslides in Zhouqu, Gansu province, China, 2010.

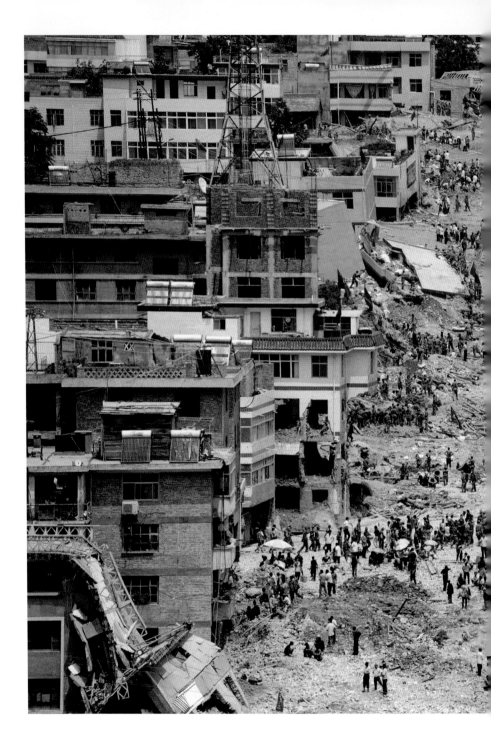

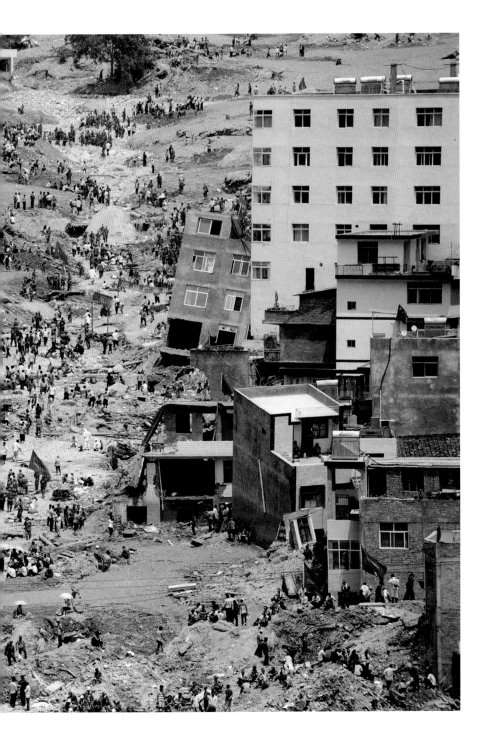

local indicator emerged from the UK. The Thames Flood Barrier was closed just four times in the 1980s, 35 times in the 1990s and more than 80 times from 2000 to 2010. The giant reinsurance company Munich Re calculated that 2011 was the costliest year in history for natural disasters globally, and a UN report of the same year stated that the number of natural disasters had quintupled over the previous four decades and that most of the increase could be attributed to what it called 'hydro-meteorological' events, including storms and floods.[12] Using data from the Centre for Research on the Epidemiology of Disasters at the University of Louvain in Belgium, it said that in the early 1970s there were always fewer than 30 major floods a year. From then until the late 1990s the number was always below 100. Since that time the figure has always been above 100, with a peak of more than 220 being reached in 2006, while for 2009 the total was around 150. According to the Asian Development Bank, more than 40 million people had been driven from their homes by 'extreme weather' in 2010 and 2011 alone, while a joint report from the UN and the African Development Bank in 2011 warned that floods were set to 'increase both in frequency and intensity'.[13]

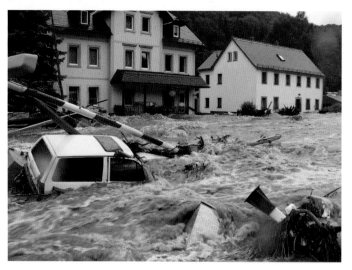

Floodwaters surge through Schlottwitz, Germany, 2004.

previous: Aftermath of the mudslide in Zhouqu County, Gansu province, China, 2010.

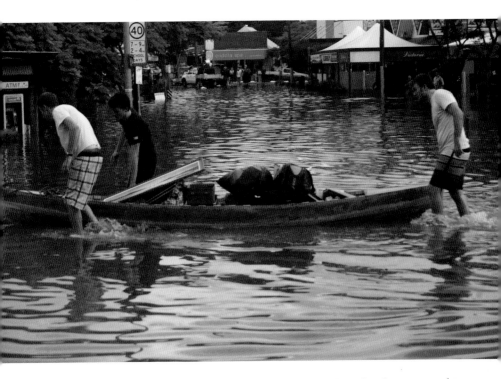

Queensland flood, 2011.

One reason to expect more damage from flooding now and in the future is simply that there are more people in the world, and most of them have more possessions. In 1950 the population of the world was 2.5 billion. In 2011 it passed 7 billion and by 2050 it is forecast to reach 9.3 billion. But that is not all. Recent years have seen a big increase in the numbers living and working in areas known to be prone to flooding. By 2007, according to the UN, more than 200 million people were inhabiting coastal areas at risk of inundation from intense storms and rising waters. The way economic development puts more people and property in danger was perfectly illustrated in Bangkok in 2011. Thailand's low-lying central provinces to the north of the capital had always been prone to flooding, as they provided a safety valve for excess water in the Chao Phraya river, with serious events in 1942, 1983 and 1995. Once the country's rice bowl, over the last few decades the area has increasingly become the home of multinational companies on industrial estates. In August 2011 Thailand's first

woman prime minister, the rather glamorous Yingluck Shina - watra, took office just as the country began experiencing its worst floods in half a century. There had been unusually heavy rain from March onwards, then in late July Tropical Storm Nock-Ten had triggered flooding in sixteen provinces in northern Thailand. By late August the water was a foot and a half (45 cm) deep in the town of Nan close to the border with Laos, while Phitsanulok province to the south was seeing its worst floods for sixteen years, and the death toll had risen to almost 40. The next month nearly all the lower central provinces had been hit. Thailand was a deeply divided country. Yingluck's brother had been deposed in a military coup five years before and then exiled for corruption. Her support was drawn mainly from the 'red shirts' to be found among the poorer sections of society, while richer people tended to favour the opposition 'yellow shirts'. Soon Yingluck was under fierce attack for allegedly mismanaging the disaster, while she complained that local officials had disobeyed her instructions. In parts of the country disputes broke out about who should be protected and who flooded.

An aerial view of floodwaters north of Bangkok, 16 October 2011.

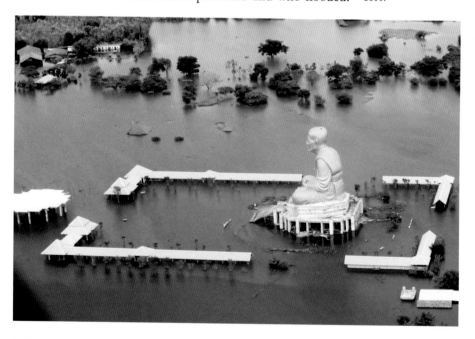

Farmers in provinces near Bangkok complained they were being sacrificed in order to protect the capital, while at Chai Nat more than 500 people set about demolishing a sandbag wall that officials had put up to limit the amount of water flowing into neighbouring Suphan Buri province, complaining that their own houses were underwater.

By the beginning of October a dozen major dams were in danger of being overwhelmed and the authorities were forced to release more water, so increasing the danger to those living downstream. The towns of Nakhon Sawan and Ayutthaya to the north of Bangkok were flooded and patients had to be moved from hospitals by boat. As the floodwaters drained southwards some of the capital's eastern districts outside its floodwall were inundated, while in Pathum Thani province, on its northern border, sandbag walls gave way. The failure of this and other barriers allowed the water to penetrate Bangkok itself, reviving uncomfortable memories of its old nickname, the 'Venice of Asia'. On 8 October a 30-foot (9-metre) barrier protecting the Rojana industrial estate in Ayutthaya province collapsed, caus-ing many manufacturing plants to flood, including Honda's, where workers tried to save new cars by driving them on to bridges and high ground. A team of divers had to go into the treacherous oily waters of a submerged rubber factory with zero visibility to attempt to salvage equipment. An engineer there said that it would take at least a year, possibly two, to recover from the disaster. Seven major industrial estates were flooded and altogether around 14,000 companies were affected, causing 650,000 workers to be laid off. Toshiba halted production at ten of its eleven plants in the country, while Toyota, Hitachi, Canon and Nikon were all hit. Honda had to close down for six months. Thailand had been producing around half of the world's com-puter hard drives. One leading manufacturer, Western Digital, had two of its factories knocked out, representing about 60 per cent of its total production.

In some areas the floods did not clear until January 2012. By then more than 800 people had died and 13 million had been caught up in the disaster, while 65 of Thailand's 77 provinces had

been declared flood disaster zones. The floods cut Thailand's GDP by 9 per cent and, according to one estimate, set back global industrial production by 2.5 per cent. The World Bank put the total cost at $46 billion, making it one of the half-dozen costliest disasters of the last 30 years. With some foreign companies shutting down completely after the flood, and others demanding 'clear-cut actions' from the government,[14] Thailand announced £6 billion worth of measures to stop flooding by the Chao Phraya, such as planting trees and building dykes along its tributaries, creating huge water-retention zones in areas that had been flooded and cleaning up canals and waterways. Thailand's Industrial Estate Authority promised to strengthen dykes around the seven industrial estates that were shut by the floods, but critics, such as the president of the Engineering Institute of Thailand, were worried that the government was rushing into short-term measures without making a proper strategic assessment of their effects. Meanwhile people's homes had suffered more damage than they would have done in times gone by because of growing affluence. Once, in regions prone to flooding, the population had lived in houses on 10-foot (3-metre) stilts. Now, complained the deputy mayor of one of the stricken towns, 'they park their cars under the house' or 'add an extra floor' in the empty area where excess water had once been able to flow without causing damage.[15]

What happened in Thailand was seen as a warning for other parts of Southeast Asia where towns and cities were encroaching on areas that had at one time provided natural protection against floods, such as wetlands, sand dunes and mangrove swamps. In the 30 years following 1980 the population of Indonesia's capital, Jakarta, and the metropolitan area around it had more than doubled to over 27 million; by 2020 it is expected to increase further to 35 million. Land that had once soaked up overflow from the city's thirteen rivers had been built on, while the rivers themselves were often blocked by rubbish. After major floods in 2002 and 2007 the government came up with plans to dredge canals, rivers and reservoirs. Also in 2007 the Organisation for Economic Cooperation and Development published a report on coastal flooding which predicted that by 2070, eight of the

A few of Jakarta's
many skyscrapers.

world's ten most vulnerable cities will be in Asia, with Kolkata
having most people at risk – perhaps 14 million – followed by
Mumbai, Dhaka, Guangzhou and Ho Chi Minh City. Bangkok
was seventh. The only city from a developed country to be listed
was Miami.

Flooding may have become more of a threat simply because there
are more people to be flooded, particularly in danger areas, but
there are also specific human activities that could be increasing
the problem. One of the reasons for Jakarta's growing vulner-
ability is the way its land has been compacted by heavy buildings.
With the Java Sea rising, this meant that by 2012, 40 per cent of
the city was below sea level. Even some apparently innocuous
changes can have serious effects. Hardened urban surfaces such
as roads, pavements and car parks do not soak up water as well
as soil. Instead it runs off rapidly, making flooding more likely. In
2005 the London Assembly in the UK tried to discourage people
from paving over their gardens – something they calculated that
more than 1 million households in the capital had already done.
Two years later, after record rainfall in June and July 2007, Britain
was hit by devastating floods that drove 55,000 families from
their homes and caused damaged estimated at £3 billion or more.

The government responded with the Flood and Water Management Act of 2010, which required wider use of permeable paving that water can seep through.

Back in 1978, in the aftermath of devastating monsoon floods in India, fingers of suspicion were pointed at another human activity: deforestation. The environmental activist Sunderlal Bahuguna demanded an end to felling. Inspired by him, women hugged trees to try and stop contractors cutting them down, while Bahuguna declared: 'Every tree is a sentry against the floods.'[16] Three decades later, when 1,100 people were killed by landslides triggered by heavy rain around Zhouqu in China in 2010, local people pointed furiously to a report from Lanzhou University four years earlier which had declared that hills in the area had become highly unstable because of 'deforestation, exploitative mining activities, construction of hydroelectric power plants and other development activities'.[17] They complained that this was just one of a series of warnings the authorities had received. It was calculated that more than 300,000 acres of forest had been felled between 1952 and 1990. A local farmer, looking for five of his relatives buried in the mud, complained that the government was well aware of the risk of disaster but did nothing to prevent it. Across the globe a similar refrain was heard in Uganda, where landslides killed hundreds in the same year. President Museveni criticized farmers for stripping thick vegetation from hillsides, opening a clearer run for floods and landslides. The government tried to combat the danger by asking half a million inhabitants to relocate away from the area at risk, but Arthur Makara from Uganda's Science Foundation for Livelihoods and Development admitted that it was difficult to get people to move 'because they are so attached to their land'.[18]

But the most feared phenomenon is global warming. Most, though not all, scientists now believe that we humans are heating up the planet. The Intergovernmental Panel on Climate Change was established in 1988 by the UN Environment Programme and the World Meteorological Organization to assess the scientific evidence for climate change and suggest appropriate responses. Its work is carried out by thousands of experts all over the world,

and in 2007 it won the Nobel Peace Prize. In that year the panel declared that the evidence for global warming was now 'unequi vocal', and that most of the change had happened since the middle of the twentieth century, meaning that it was likely to have been caused by human activity.[19] In 2011 America's National Oceanic and Atmospheric Administration reported that the first eleven years of the twenty-first century were all among the hottest thirteen since its records began in 1879. This ominous cocktail of global warming, growing numbers of humans and diminishing opportunities for water to soak away conjures up a number of disaster scenarios. None are quite as apocalyptic as humanity's ancient deluge myths, but they threaten to kill many people and make many more extremely miserable.

The first danger from climate change is a surprising one. Floods often send people racing for refuge to higher ground, but the estimated 800 million people who now live in the world's mountain regions may themselves be in danger. When Sir Edmund Hillary and Tenzing Norgay climbed Mount Everest in 1953 there was no such thing as Lake Imja. Now, at 16,000 feet (5 km) high and 1.5 miles (2.4 km) long, it is the fastest-growing of more than 1,500 glacier lakes in Nepal, fed by chunks of ice falling from

Global warming protest, Helsinki, Finland.

cliffs above as temperatures rise. More than 600 yards (550 m) wide at its centre, and up to 300 feet (90 m) deep, every year it expands by another 50 yards (45 m). If it were to break through the moraine – a natural wall of glacial debris – holding it back, it could flood houses and fields for 60 miles (95 km), burying them under rubble up to 50 feet (15 m) thick. Scientists who have made the nine-day trek to study Imja believe that before long, the natural dam will burst, causing a so-called glacial lake outburst flood (GLOF). When glacial lakes burst they can send up to a million cubic metres of water crashing as fast as an anti-tank missile into the valleys beneath. And such events tend not to be one-off disasters. Instead they trigger floods and landslides year after year. A few years ago fears about Imja grew so acute that visiting experts persuaded villagers to pack up and move away. Then, when nothing happened, they returned home, but the head of a local environmental group thinks they are still in danger, describing the growth of the lake as 'really scary'.[20] The international

Lake Imja, Himalayas.

grass-roots conservation organization the Mountain Institute called in Peruvian experts from the Andes who have built tunnels and channels to drain more than 30 glacier lakes since the devastating Lake Palcacocha disaster of 1941, but they said it would be extremely difficult to do anything similar at Imja because the lake was so inaccessible. The Nepalese government regards it as just one of perhaps eighteen high-risk mountain lakes. In its *Global Outlook for Ice and Snow*, compiled by 70 experts across the world in 2007, the UN concluded that many glaciers were already receding as temperatures rose, identifying the Himalayas, Tien Shan and the Pamir Mountains of Central Asia as well as the Andes and the Alps as areas at risk, and pointing to GLOFs in Central Asia in 1998 and 2002 that had claimed more than 100 lives. In its *Summary for Policymakers* of 2011 the IPCC agreed that it was probable that GLOFs would become more frequent.

Global warming may also increase flooding through another means – fiercer and more widespread storms. The IPCC announced soberly in 2011: 'It is likely that the frequency of heavy precipitation or the proportion of total rainfall from heavy falls will increase in the 21st century over many areas of the globe.'[21] In March 2004, for the first time, meteorologists saw a hurricane develop off the coast of Brazil before making landfall in Catarina state, where it killed three people and destroyed about 1,500 homes. A report from an American meteorologist in 2005 concluded that storms in the north Atlantic and the western north Pacific were lasting 60 per cent longer and were 50 per cent more powerful than in 1949, though some of this effect might be caused by changes in methods of reporting. In August of that year what was described by the United States Secretary of Homeland Security Michael Chertoff as 'probably the worst catastrophe or set of catastrophes certainly that I'm aware of in the history of the country' struck America.[22] Hurricane Katrina did enormous damage in Mississippi and Louisiana, especially New Orleans. When it arrived on 29 August the Big Easy was spared a direct hit, but any notion that the city had got off lightly was dispelled as floods struck. Heavy rain combined with storm surges to breach New Orleans's defences at more than 50 points, gouging gaps

that were sometimes hundreds of feet long. The mayor ordered an evacuation – one of the biggest in American history – but tens of thousands decided to stay. Within 24 hours around 80 per cent of New Orleans was underwater, with stranded people having to be plucked off roofs by helicopters. There was widespread looting. The National Guard was called in and martial law declared. Some of those who had stayed took refuge in the Convention Center or the Louisiana Superdome. The stadium was described by one reporter as being 'like a concentration camp'.[23] Food and water was short. Toilets overflowed, temperatures soared into the nineties and there were stories of shootings and sexual assaults, though later questions were raised as to whether the tales of violence had been exaggerated. Some parts of the city became submerged to a depth of 25 feet (7.5 metres), and Chertoff described seeing 'houses that were crushed like match sticks' and meeting 'people who had seen their entire lives just evaporate before their eyes'. New Orleans was 'largely under

Tien Shan mountain range.

water, tossed about as if it's merely a set of child's toys. The devastation, the damage to life, the damage to the entire infrastructure of the city is breathtaking and horrifying.'[24] One of Louisana's senators flew over the scene in a helicopter and likened it to the aftermath of the Boxing Day Tsunami in Indonesia.

Altogether more than 1 million people were evacuated from their homes, with a quarter of them going to Texas. Many ended up at the Houston Astrodome, where they had to sleep on camp beds surrounded by their few remaining possessions, stashed in laundry bags. More than 1,800 people were killed, the vast majority of them in Louisiana. In New Orleans bodies had to be tied to lamp posts to stop them floating away, while 40 corpses were discovered in a flooded hospital. Former president Bill Clinton was one of many who complained about what he considered the government's inadequate response, saying that black people and the poor had borne the brunt of the disaster. One police officer said of the authorities: 'They did nothing to prepare for this. They just rolled the dice and hoped for the best.'[25] The head of the Federal Emergency Management Agency resigned, and President George W. Bush had to apologize for 'serious problems in our response capability at all levels of government'.[26]

Damage from
Hurricane Katrina,
New Orleans.

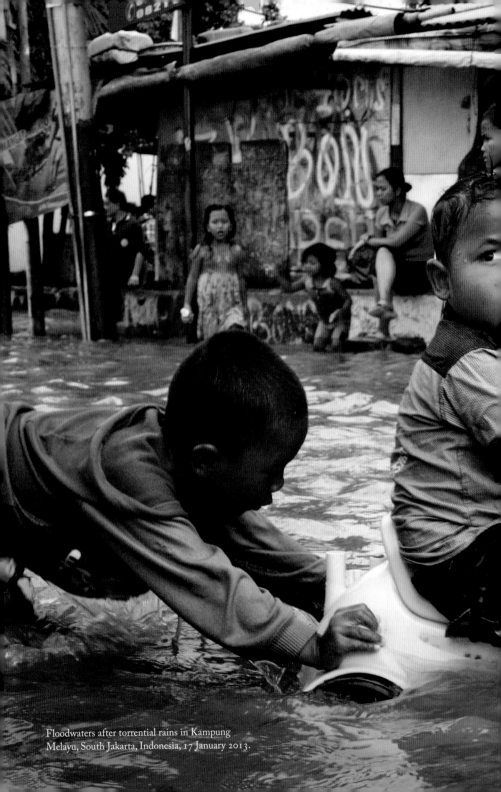

Floodwaters after torrential rains in Kampung
Melayu, South Jakarta, Indonesia, 17 January 2013.

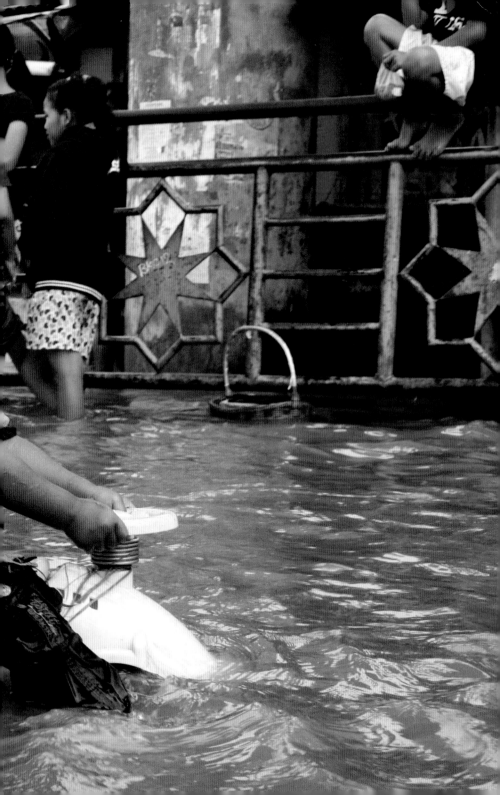

The disaster was a terrible blow to America's self-esteem. It had taken more than 40 days after Katrina struck for u.s. Army engineers to pump out the last of the water, and a year later the city still stank from the filth it had left behind. Most people had not yet returned, and a social worker remarked: 'We're in an American city and there's just miles and miles of devastation.'[27] Even five years after Katrina, it was estimated that 100,000 of the city's former inhabitants had not come back. Houses lay empty, some in a state of collapse, and there had been a 45 per cent rise in the number of people suffering chronic health problems. After the disaster thousands had been put up in poorly ventilated trailers; mould and spores had sprouted in the houses that were still habitable and there was no electricity. Unsurprisingly there was a leap in lung and skin problems. Many people were unemployed for months and left homeless for years. The proportion suffering from mental health problems tripled and the suicide rate doubled. Katrina ended up as probably America's costliest natural disaster, and by some measures the third costliest in human history, with a price tag of over $80 billion. It seemed to illustrate the impotence of even the most powerful nation on earth against these new dangers.

Only a few weeks after Katrina, Guatemala was given an equally sharp demonstration of the increased danger of floods brought by more vociferous weather as Tropical Storm Stan unleashed fearsome mudslides on dozens of villages, killing perhaps 2,000 people. A teacher whose school had been destroyed lamented that 'There are no words for this. I have only tears left', while Francisco Diaz from Médecins Sans Frontières reminded the world who generally suffers most if the environment becomes more hostile: 'The poorest villages are also the most vulnerable because they are less well equipped.'[28]

The best-known hazard from global warming is the rise it causes in sea level because of the expansion of water as it warms. The IPCC calculated that during the twentieth century the oceans rose by between 5 and 9 inches (13–23 cm), but from 1993 to 2003 the rate of increase accelerated by about half. Over the next century it predicted a further rise of up to 17 inches (43 cm),

An island in the
Maldives.

though the panel acknowledged this might be an underestimate.
In many parts of the world people complained they were already
witnessing the effects of rising sea levels. One resident of Maputo
ruefully noted: 'The water is eating the land.'[29] It was a change
that might make some small islands uninhabitable. Indeed, back
in 1992 President Maumoon Abdul Gayoom of the Maldives had
addressed the UN Earth Summit, saying:

> I stand before you as a representative of an endangered people.
> We are told that as a result of global warming and sea-level
> rise, my country, the Maldives, may some time during the
> next century, disappear from the face of the Earth.[30]

The president knew what he was talking about. In 1987 tidal
surges had flooded the islands, causing millions of pounds' worth
of damage, while the Boxing Day Tsunami of 2004 would again
swamp most of them. But one of the IPCC report's main editors,
Professor Chris Field from Stanford University, gave a reminder
that global warming was not just a threat to low-lying islands:
'There is disaster risk almost everywhere.'[31] Even in the temper-
ate UK, a government report in 2012 concluded that climate change
would greatly increase the danger of flooding, stating that the

number of people at risk could more than double to 3.6 million by 2050. But the increase in sea level does not only happen because water expands as it warms; the effect is augmented by melting ice at the North and South Poles. In the Arctic Ocean ice has been in steady decline since at least the 1960s. By 2005 it had fallen to half the level of 40 years before and in 2012 the area it covered was the smallest since modern recording methods began. And it is not just a matter of volume – rising temperatures in the oceans also produce dangerous changes in their currents, making the effect more severe in some places than others. According to the u.s. Geological Survey of 2012 for 600 miles (965 km) from North Carolina to Massachusetts, sea levels have been rising at a much faster rate than the average 2 inches (5 cm) for the rest of the world since 1990. For New York City the increase was 2.8 inches (7.1 cm), for Philadelphia 3.7 inches (9.4 cm) and for Norfolk, Virginia, 4.8 inches (12.2 cm). The report's lead author, Asbury Sallenger Jr, said it was like a car 'jamming on the accelerator', adding that by the year 2100 the water along the United States East Coast could rise by an extra 11 inches (28 cm).[32] On the other side of the country a report in 2012 from the National Research Council reckoned that Oregon and Washington could face a rise in sea level of 2 feet (60 cm) by 2100, while California

Arctic ice melting. Tigvariak Island, Alaska, 1950.

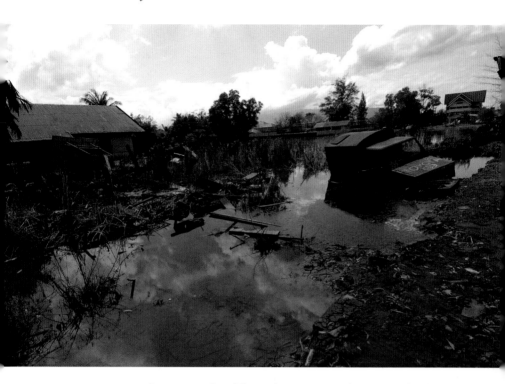

Devastation in Banda
Aceh, Sumatra,
Indonesia, 9 January
2005, nearly 2 weeks
after the Boxing Day
Tsunami.

might expect 3 feet. These changes can make a storm flood much
more devastating even if there is no increase in the storm's power.

It was this kind of arithmetic that persuaded the New York
State Energy Research and Development Corporation to com-
mission a report on the city's vulnerability to floods which was
published in 2011. Four of New York's five boroughs are islands,
and the metropolis has almost 600 miles (965 km) of coastline,
while most subway and tunnel entrances are only just above sea
level. The report concluded that as the sea rises, a hurricane like
Irene of 2011, which brought fierce rainstorms to New England
and destroyed bridges in Vermont and New York State, could put
one-third of the city underwater and flood the subway system
and many of the tunnels leading into Manhattan. The report got
a reality check the following year when Superstorm Sandy – at
900 miles (1,450 km) wide the largest ever seen in the Atlantic
– smashed into the Big Apple with a record 14-foot (4-m) tidal
surge and caused damage all along the coast of the eastern United

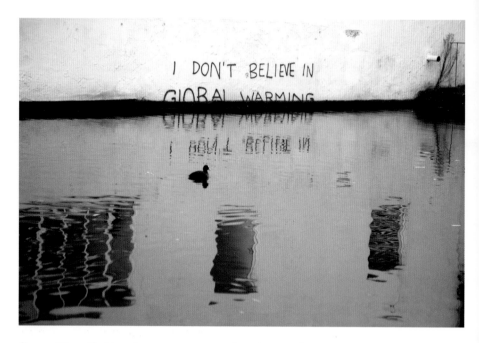

States. New York's subway system was shut down when seven tunnels under the East River were flooded, as well as many stations, and all but one of the road tunnels to Manhattan were also underwater. With bridges closed too, the island was effectively cut off. Power stations were knocked out, leaving 4.5 million Americans without electricity, and the National Guard were called out to deliver emergency food supplies. Mayor Bloomberg ordered the evacuation of 375,000 people from New York City, though many stayed put to guard their homes. Some were among the 37 people in New York State who died. New Jersey also suffered severe damage. Along the whole of the East Coast the death toll was more than 80.

Graffiti by Banksy, Camden, London.

Not everyone is convinced that climate change exists. An analysis of the views of 48 Republican candidates for the u.s. Senate's mid-term elections in November 2010 suggested that all but one either denied its existence or opposed any action to combat it, while Rick Santorum, running for the presidential nomination, declared on television: 'There is no such thing as global warming.'[33] Some politicians may doubt it, but the imaginations of

artists are already populated by images of the floods that climate change might inflict on our planet. We have seen how novelists like Maggie Gee and Stephen Baxter and films such as *Water - world* have conjured up visions of a sodden future. After the UN's Copenhagen conference failed to set legally binding targets for limiting climate change in 2009, the British graffiti artist Banksy took Santorum's message 'I don't believe in global warming' and painted it on a wall above a London canal in a way that made the letters seem to be disappearing beneath the water. Perhaps the most disturbing images have been photographs, which even in the Photoshop era carry a hint of the camera's would-I-lie-to-you? authority. In the same year that Banksy's message appeared two illustrators, Robert Graves and Didier Madoc-Jones, produced a series of imagined landscapes showing the effects of global warming on London, entitled *Postcards from the Future*, which were exhibited at that respected repository of the capital's history, the Museum of London. One – *London as Venice* – visualizes the impact of a 20-foot rise in water levels. In the foreground the sun shines on Westminster Abbey and the Houses of Parliament, now islands in a lake. It looks serene, but that is because, the artists' caption informs us, unlike the iconic Italian city, London is now uninhabitable. The American artist Alex Lukas has produced similar images of New York but in a much deeper flood.

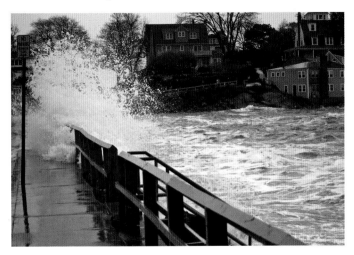

Flooding in Marble-head, Massachusetts, caused by Superstorm Sandy, 2012.

This disaster goes far beyond any scenario imagined by the New York State Energy Research and Development Corporation. Now only the tops of the very tallest buildings poke out above the enveloping sea. The scene is as tranquil as a Sisley or a Pissarro painting, but much more sinister. The flood has conquered and silenced the great metropolis.

Postscript

On the day I started writing the previous chapter in July 2012 in London, the UK had 106 flood alerts and the Environment Agency said that 5 million homes were at risk. We had just had the wettest June on record, preceded by the wettest ever April. There had been severe flooding over the previous couple of days in the southwest of England and in Durham, Derbyshire and County Down, and people had been evacuated from their homes in Lancashire and Herefordshire. Some places had still not recovered from the previous month's floods, which hit many parts of the country, including Lancashire, Yorkshire, Shropshire, Ceredigion and Sussex, and both main rail lines connecting London and the North were blocked. Further afield, in India, more than 230 lives had been lost in monsoon floods, some described as the worst in more than 60 years, and in Bangladesh at least 100 people had died. In southern Russia, more than 170 had been drowned by flash floods after 11 inches (28 cm) of rain fell in a single night. Torrential rain caused the deaths of more than twenty people and the evacuation of a quarter of a million in Japan, while at least 37 people perished in China in Beijing's worst floods since records began. In North Korea the death toll from typhoons and rain was 88.

Are all these misfortunes just further confirmation that floods have always been the disaster most likely to afflict humanity? Is any impression that there has been a step change in the dangers we face an illusion? Does it derive from the tendency we all have to over-emphasize the uniqueness of the present, or

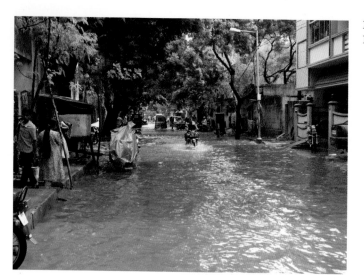

Monsoon rain, Chennai, India, 2008.

the enchantment lent by the distance of time that makes us remember all summers as sunny when we were young? Are we witnessing nothing more than the normal ups and downs of the climate? Or are those calculations by so many scientists right: does mankind now face a struggle with floods the like of which we have never seen before?

NOTABLE FLOODS

365 The Great Tsunami – Egypt, Greece and four other countries. 50,000 killed.

838 Storm surge, Netherlands. Up to 2,500 killed.

1362 Grote Mandrenke, the Great Drowning of Men – Netherlands, Denmark, Germany. 25,000 killed.

1570 All Saints' Flood, Netherlands. 4,000 killed.

1607 Severn flood – England and Wales. 2,000 killed.

1642 Yellow River, China. 300,000 killed.

1703 Tsunami, Japan. Up to 100,000 killed.

1824 St Petersburg flood, Russia. Up to 569 killed.

1887 Yellow River, China. 900,000–2.5 million killed.

1889 Johnstown dam burst, USA. 2,200 killed.

1896 Sanriku tsunami, Japan. 27,000 killed.

1900 Galveston hurricane, USA. 12,000 killed.

1927 Mississippi flood, USA. 300 killed.

1931 Yellow River and Yangtze, China. Up to 3.75 million killed.

1938 Yellow River, China. Up to 800,000 killed.

1941 Lake Palcacocha overflow, Peru. Up to 7,000 killed.

1953 North Sea storm surge – UK and Netherlands. 2,150 killed.

1970 Bangladesh cyclone. Up to 1 million killed.

1975 Dam bursts, China. Up to 230,000 killed.

1991 Bangladesh cyclone. 138,000 killed.

1998 Hurricane Mitch – four countries including Honduras. Up to 19,000 killed.

1999 Venezuela mudslide. Up to 30,000 killed.

2000 Mozambique flood. 800 killed.

2004 Boxing Day Tsunami – fourteen countries, including Indonesia, Sri Lanka, India and Thailand. 230,000 killed.

2005 Hurricane Katrina, USA. 1,800 killed.

2005 Tropical Storm Stan mudslides, Guatemala. Up to 2,000 killed.

2008 Cyclone Nargis, Myanmar (Burma). Up to 140,000 killed.

2010 Pakistan monsoon flood. 1,750 killed.

2010 Zhouqu mudslides, China. 1,100 killed.

2011 Thailand monsoon floods. 800 killed.

REFERENCES

1 Myth

1 *The Epic of Gilgamesh*, trans. N. K. Sandars (Harmondsworth, 1975), pp. 97, 108, 109.
2 Ibid., pp. 110, 111.
3 Sir Leonard Woolley, *Ur of the Chaldees* (Harmondsworth, 1942), pp. 19, 20.
4 Ovid, *Metamorphoses*, trans. Frank Justus (London, 1946), vol. I, pp. 9, 11, 15, 23, 25.
5 Ibid., pp. 25, 29, 31.
6 Sir James George Frazer, *Folk-lore in the Old Testament: Studies in Comparative Religion Legend and Law* (London, 1919), vol. I, p. 184.
7 8th Adhyaya 1st Brahmana, The Ida 7, at www.sacred-texts.com.
8 Frazer, *Folk-lore*, vol. I, p. 107.
9 Ibid., p. 228.
10 James MacKillop, *Myths and Legends of the Celts* (London, 2005).

2 Reality

1 G. N. Garmonsway, ed. and trans., *The Anglo-Saxon Chronicle* (London, 1975), p. 235.
2 Robert Doe, *Extreme Floods* (London, 2006), pp. 45, 12.
3 William G. Naphy and Penny Roberts, *Fear in Early Modern Society* (Manchester, 1997), p. 65.
4 *God's Warning to His People of England*, http://website.lineone.net, accessed 27 February 2013.
5 Ibid.
6 'The Yellow River Inundations', *The Times*, 11 January 1888, p. 4.
7 'The Hankow Floods', *The Times*, 22 August 1931, p. 10.
8 'The Yangtze Floods', *The Times*, 18 September 1931, p. 13.

9 Ibid.
10 'Famine Camps in China', *The Times*, 6 April 1932, p. 15.
11 Report of the National Relief Flood Commission, 1931–2, http://archive.org, accessed 12 February 2013.
12 Jasper Becker, *Hungry Ghosts: China's Secret Famine* (London, 1996), p. 77.
13 'After 30 Years, Secrets, Lessons of China's Worst Dams Burst Accident Surface', *People's Daily* online, 1 October 2005, http://english.people.com.cn.
14 Nigel Cawthorne, *100 Disasters that Shook the World* (London, 2005), p. 137.
15 'After 30 Years'.
16 'Indian Ocean Tsunami Survivor Remembers Boxing Day 2004', www.bbc.co.uk/news, 13 April 2010.
17 'Survivors Tell of Tsunami Train Horror', www.bbc.co.uk/news, 30 December 2004.
18 'Inquiry into Deaths of UK Tsunami Victims Begins', *Guardian*, 5 December 2005, www.guardian.co.uk.
19 Ibid.
20 'Tsunami "Miracle" Woman Pregnant', www.bbc.co.uk/news, 6 January 2005.
21 'After the Tsunami: The Rebuilding Starts', *The Economist*, 5 February 2005.
22 Edith M. Lederer, 'UN: Tsunami Generated Unprecedented Aid', Associated Press, http://infoweb.newsbank.com, 19 December 2005.
23 Cawthorne, *100 Disasters*, p. 64.
24 Arnold Zeitlin, 'Pitiful Remnants of Life Seen on Air Tour of Pakistan Areas Ravaged in "Worst Disaster of Humankind"', *The Times*, 17 November 1970, p. 8.
25 Michael Pollard, *North Sea Surge: The Story of the East Coast Floods of 1953* (Lavenham, 1978), p. 64.
26 Hilda Grieve, *The Great Tide: The Story of the 1953 Flood Disaster in Essex* (Chelmsford, 1959), pp. 155, 159.
27 *Timewatch*, broadcast in the UK on BBC2, 31 October 2003.
28 Grieve, *The Great Tide*, pp. 365, 404.
29 Pollard, *North Sea Surge*, p. 71.
30 Grieve, *The Great Tide*, p. 389.
31 Serge F. Kovaleski, 'Death Is Everywhere', *Washington Post*, 21 December 1999.
32 Will Grant, 'Venezuela Flood Victims Still Live in Ruins 10 Years On', www.bbc.co.uk/news, 15 December 2009.
33 Kovaleski, 'Death Is Everywhere'.
34 'Victims Tell of Flood Nightmare', www.bbc.co.uk/news, 20 December 1999.

3 Description: Floods in Literature

1 Mary Mapes Dodge, *Hans Brinker, or The Silver Skates* (London, 1985), pp. 127, 128.
2 Ibid., pp. 129, 130.
3 Emile Zola, *The Flood* (Milton Keynes, 2012), pp. 6, 7, 9, 10.
4 Ibid., pp. 11, 13, 15.
5 Ibid., p. 24.
6 Ibid., pp. 32, 35.
7 'Hurricane and Inundations at Petersburgh and Cronstadt', *The Times*, December 15 1824, p. 2.
8 Alexander Pushkin, 'The Bronze Horseman', in *Selected Verse*, trans. J. Alexander Fennel (London, 1991), pp. 238, 241, 242, 243, 245.
9 Ibid., pp. 245, 247.
10 George Eliot, *The Mill on the Floss* (London, 1969), pp. 475, 479–81.
11 Ibid., p. 485.
12 Mervyn Peake, *Gormenghast* (Harmondsworth, 1980), pp. 408, 409, 424, 426.
13 Ibid., pp. 427, 432.
14 Ibid., pp. 501, 504.
15 Andrew Marvell, 'Upon Appleton House', in *The Complete Poems* (London, 1984), p. 78.
16 William Faulkner, *Old Man*, in *Three Famous Short Novels* (New York, 1994), p. 115.
17 Ibid., pp. 120, 132, 136.
18 Ibid., pp. 166, 175, 181.
19 Bernard Malamud, *God's Grace* (London, 1982), pp. 4, 3, 5, 6.
20 Penelope Lively, *The Voyage of QV66* (London 1990), pp. 4, 15.
21 J. G. Ballard, *The Drowned World* (London, 2008), pp. 10, 53, 14.
22 Ibid., p. 175.
23 Maggie Gee, *The Flood* (London, 2005), pp. 7, 221.
24 Ibid., pp. 306, 308.
25 Stephen Baxter, *Flood* (London, 2008), p. 44.
26 Ibid., pp. 141, 221.

4 Depiction: Floods in Art and Films

1 Kirsteen McSwein, *John Martin: Apocalypse,* exh. leaflet, Tate Britain, London, 2012.
2 Charles C. Eldredge, *John Steuart Curry's Hoover and the Flood: Painting Modern History* (Chapel Hill, NC, 2007), p. 22.
3 Ibid., pp. 56, 8, 8.
4 Jackson J. Spielvogel, *Western Civilization* (Belmont, CA, 2008), vol. III, p. 738.

5 John T. Soister, *Up from the Vault: Rare Thrillers of the 1920s and 1930s* (Jefferson, NC, 2010), p. 149.
6 Roger Ebert, '*The Day After Tomorrow*', *Chicago Sun-Times*, 28 May 2004, http://rogerebert.suntimes.com
7 Peter Travers, '*The Day After Tomorrow*', *Rolling Stone*, 28 May 2004, www.rollingstone.com; Anthony Lane, '*The Day After Tomorrow*', *New Yorker*, 7 June 2004, www.newyorker.com.
8 Nancy Banks-Smith, 'This Weekend's TV', *Guardian*, 5 May 2008, www.guardian.co.uk.
9 Janet Maslin, 'Film Review: *Waterworld*', *New York Times*, 28 July 1995, www.nytimes.com.

5 Defence

1 William George Aston, *Shinto: The Way of the Gods* (Boston, MA, 2005), p. 152.
2 Sir Austen Henry Layard, *Nineveh and Its Remains* (London, 1970), p. 68.
3 'World's Highest Dam Turns Valley into Lake', *Popular Science* (September 1927), p. 37.
4 Frommer's Destination, www.frommers.com, accessed 21 May 2012.
5 Woody Guthrie, *Roll on Columbia*, www.woodyguthrie.org, accessed 21 May 2012.
6 John MacGowan, *A History of China from the Earliest Days Down to the Present* (Charleston, NC, 2009), p. 18.
7 American Society of Civil Engineers, 'Netherlands North Sea Protection Works', www.asce.org, accessed 21 May 2012.
8 Alan Hamilton, 'Thames Barrier: Holding Back the Relentlessly Rising Waters', *The Times*, 15 November 1982, p. 10.
9 Teri Karush Rogers, 'The Real Riddle of Changing Weather: How Safe Is My Home?', *New York Times*, 11 March 2007, www.nytimes.com.
10 Anthony Doesburg, 'Car Parks and Playgrounds to Help Make Rotterdam "Climate Proof"', *Guardian*, 11 May 2012, www.guardian.co.uk.
11 William J. Broad, 'In Europe, High-tech Flood Control, With Nature's Help', *New York Times*, 6 September 2005, www.nytimes.com.
12 Juliette Jowit, 'Engineers Go Back to Nature to Fight Floods', *Guardian*, 13 June 2004, www.guardian.co.uk.

6 Defeat?

1 Audio slideshow: 'I Gave Birth in a Tree', www.bbc.co.uk/news, 22 February 2010.

2 'Rains Threaten Flood-Hit Africa', www.bbc.co.uk/news, 15 September 2007.

3 David Smith, 'Benin Suffers Worst Floods since 1963', *Guardian*, 25 October 2010, www.guardian.co.uk.

4 'Hundreds Feared Dead after Uganda Landslides', www.bbc.co.uk/news, 3 March 2010.

5 'UN Launches $459m Pakistan Flood Appeal', www.bbc.co.uk/news, 11 August 2010.

6 Saeed Shah, 'Pakistan Floods: "By the Time I Had Got the Children, the Water was Waist High"', *Guardian*, 3 August 2010, www.guardian.co.uk.

7 'Bereaved Pakistanis Speak of Flood Horrors', www.bbc.co.uk/news, 5 August 2010.

8 'Pakistan Floods: Your Stories', www.bbc.co.uk/news, 3 August 2010.

9 Ibid.

10 'President: Colombia Hit by "Worst Natural Disaster"', *Focus on Colombia*, NBC News, 26 April 2011, www.msnbc.msn.com.

11 'Queensland Rebuilding "Huge Task"', www.bbc.co.uk/news, 13 January 2011.

12 *United Nations World Economic and Social Survey 2011*, www.un.org, p. 102, accessed 12 July 2012.

13 'Save our Cities', *The Economist*, 17 March 2012, p. 58; 'Africa Report on New and Emerging Challenges', www.uneca.org, accessed 12 July 2012.

14 Ploy Ten Kate, 'Thailand in Hurry to Put Flood Defences in Place', Reuters Africa, 19 January 2012, http://af.reuters.com.

15 Alisa Tang, 'Floating Buildings Could Help Thais Tackle the Flooding Crisis', *Guardian*, 14 February 2012, www.guardian.co.uk.

16 Richard Wigg, 'Ecologist Calls for Ban on Himalayan Tree Felling', *The Times*, 10 October 1978, p. 5.

17 Peter Foster, 'China Landslide Death Toll Tops 1,100', *Daily Telegraph*, 11 August 2010, www.telegraph.co.uk.

18 'At Least 23 Dead in Ugandan Landslides', *Irish Times*, 30 August 2011, www.irishtimes.com.

19 United Nations Environment Programme Press Release, 2 February 2007, www.unep.org. The report: Intergovernmental Panel on Climate Change, Fourth Assessment Report: Climate Change 2007, 'Working Group 1 Report: The Physical Science Basis' (2007), www.ipcc.ch.

20 Suzanne Goldenberg, 'Glacier Lakes: Growing Danger Zones in

the Himalayas', *Guardian*, 10 October 2011, www.guardian.co.uk.
21 'Managing the Risks of Extreme Events and Disasters to Advance
 Climate Change Adaptation: Summary for Policymakers',
 www.ipcc-wg2.gov, p. 11, accessed 12 July 2012.
22 *CNN Live Saturday: The Aftermath of Katrina*, 3 September 2005,
 http://transcripts.cnn.com.
23 'Stadium Hurricane Refuge Like a "Concentration Camp"', Agence
 France Presse, 2 September 2005, www.commondreams.org.
24 *CNN Live Saturday: The Aftermath of Katrina.*
25 'Stadium Hurricane Refuge'.
26 Jamie Wilson and Julian Borger, 'Katrina Failings Were My Fault,
 Bush Admits for First Time', *Guardian,* 14 September 2005,
 www.guardian.co.uk.
27 Stephen Sackur, 'One Year On: Katrina's Legacy', www.bbc.co.uk/
 news, 24 August 2006.
28 'Hundreds Missing After Stan Storm', www.bbc.co.uk, 8 October
 2005; Francisco Diaz, 'Guatemala After Tropical Storm Stan',
 Médecins Sans Frontières, 31 October 2005,
 www.doctorswithoutborders.org.
29 Michael Hirst and Kate McGeown, 'Rising Sea Levels: A Tale
 of Two Cities', www.bbc.co.uk, 24 November 2009.
30 Jon Hamilton, 'Maldives Builds Barriers to Global Warming', NPR,
 28 January 2008, www.npr.org.
31 'Climate Change Panel Warns of Severe Storms, Heatwaves and
 Floods', *Guardian*, 28 March 2012, www.guardian.co.uk.
32 Seth Borenstein, 'Sea Rise Faster on East Coast than Rest of
 Globe', *Business Week*, 24 June 2012, www.businessweek.com.
33 Lisa Hymas, 'Rick Santorum and Mitt Romney are Both Bad
 News for Climate Change Fight', *Guardian*, 4 January 2012.

SELECT BIBLIOGRAPHY

Ballard, J. G., *The Drowned World* (London, 2008)

Baxter, Stephen, *Flood* (London, 2008)

Becker, Jasper, *Hungry Ghosts: China's Secret Famine* (London, 1996)

Calvocoressi, Peter, *Who's Who in the Bible* (London, 1988)

Castleden, Rodney, *Natural Disasters that Changed the World* (London, 2007)

Cawthorne, Nigel, *100 Disasters that Shook the World* (London, 2005)

Dodge, Mary Mapes, *Hans Brinker; or, The Silver Skates* (London, 1985)

Doe, R., *Extreme Floods* (London, 2006)

Eldredge, Charles C., *John Steuart Curry's 'Hoover and the Flood': Painting Modern History* (Chapel Hill, NC, 2007)

Eliot, George, *The Mill on the Floss* (London, 1969)

The Epic of Gilgamesh, trans. N. K. Sanders (Harmondsworth, 1975)

Faulkner, William, *Old Man*, in *Three Famous Short Novels* (New York, 1994), pp. 79–188

Frazer, Sir James George, *Folk-lore in the Old Testament: Studies in Comparative Religion Legend and Law* (London, 1919)

Garmonsway, G. N., ed. and trans., *The Anglo-Saxon Chronicle* (London, 1975)

Gee, Maggie, *The Flood* (London, 2005)

Grieve, Hilda, *The Great Tide: The Story of the 1953 Flood Disaster in Essex* (Chelmsford, 1959)

Holford, Ingrid, *British Weather Disasters* (Newton Abbot, 1976)

Layard, Sir Austen Henry, *Nineveh and Its Remains* (London, 1970)

Lively, Penelope, *The Voyage of QV66* (London 1990)

MacGowan, John, *A History of China from the Earliest Days Down to the Present* (Charleston, NC, 2009)

Malamud, Bernard, *God's Grace* (London, 1982)

Maltin, Leonard, ed., *Leonard Maltin's Movie and Video Guide 1993* (London, 1993)

Marvell, Andrew, *The Complete Poems* (London, 1984)

Milne, Anthony, *London's Drowning* (London, 1982)
Ovid, *Metamorphoses*, vol. I, trans. Frank Justus Miller (London, 1946)
Peake, Mervyn, *Gormenghast* (Harmondsworth, 1980)
Pollard, Michael, *North Sea Surge: The Story of the East Coast Floods of 1953* (Lavenham, 1978)
Prescott, William H., *History of the Conquest of Mexico* (New York, 1998)
Pushkin, Alexander, *Selected Verse*, trans J. Fennel (London, 1991)
Ryan, William, and Walter Pitman, *Noah's Flood: The New Scientific Discoveries about the Event that Changed History* (New York, 1998)
Soister, John T., *Up from the Vault: Rare Thrillers of the 1920s and 1930s* (Jefferson, NC, 2010)
Svensen, Henrik, *The End is Nigh: A History of Natural Disasters* (London, 2012)
Turpin, Trevor, *Dam* (London, 2008)
Ward, Kaari, ed., *Great Disasters* (Pleasantville, NY, 1989)
Withington, John, *A Disastrous History of the World* (London, 2008)
Woolley, Sir Leonard, *Ur of the Chaldees: Seven Years of Excavation* (Harmondsworth, 1938)
Zola, Emile, *The Flood* (Milton Keynes, 2012)

ASSOCIATIONS AND WEBSITES

Centre for the Study of Floods and Communities, University
of Gloucestershire
www.glos.ac.uk/research/csfc

Department for Environment, Food and Rural Affairs, UK
www.defra.gov.uk

Environment Agency, UK
www.environment-agency.gov.uk

European Centre for River Restoration
www.ecrr.org

European Environmental Agency
www.eea.europa.eu

European Flood Awareness System
http://ies.jrc.ec.europa.eu/european-flood-alert-system

Flood Forecasting Centre at the Met Office and UK
Environment Agency
www.ffc-environment-agency.metoffice.gov.uk

Flood Hazard Research Centre, Middlesex University
www.fhrc.mdx.ac.uk

Flood Risk Management Research Consortium
www.floodrisk.org.uk

Global Centre of Excellence for Water Hazard and Risk
Management, UNESCO
www.icharm.pwri.go.jp

Institute of Water and Flood Management, Bangladesh University
of Engineering and Technology
www.buet.ac.bd/iwfm

Interdisciplinary Flood Institute for Teachers, University of Iowa
http://iowafloodcenter.org/event/interdisciplinary-flood-institute-
for-teachers

International Flood Initiative
www.ifi-home.info

International Network of Basin Organizations
www.inbo-news.org

National Oceanic and Atmospheric Administration, USA
www.noaa.gov

Rivers Agency of Northern Ireland
www.dardni.gov.uk/riversagency

Scottish Environment Protection Agency
www.sepa.org.uk

Scottish Flood Forum
www.scottishfloodforum.org

UNESCO-IHE Institute for Water Education
www.unesco-ihe.org

PHOTO ACKNOWLEDGEMENTS

The author and publishers wish to express their thanks to the below sources of illustrative material and/or permission to reproduce it. Locations of some artworks are also given below.

E. Benjamin Andrews: p. 107; Bill Bertram (Pixel8) 2008: pp. 136–7; The Birkes: p. 169; © The Trustees of the British Museum: pp. 13, 20, 23, 25, 83, 126, 139; Daniel Alton Byers: p. 158; Anne Clements Photography: pp. 6, 134; Corbis: p. 27 (Wolfgang Kaehler); Depositphotos: p. 104 (Antonio Abrignani); Nevit Dilmen: p. 165; Florestein: p. 66; Luca Galuzzi (Lucag): p. 80; Norman Herr: p. 119; iStockphoto: pp. 55 (jekershner7), 133 (DigiClicks); Jks93: p. 115; Gunawan Kartapranata: p. 155; Kenyon College: p. 84 (William J. Smither); Kate Lamb: pp. 162–3; Le Grand Portage: p. 125; Library of Congress, Washington, DC: pp. 10, 15, 121, 122, 128; Mattes: p. 140; M.M.Minderhoud: p. 131; National Archives and Records Administration, Washington, DC: pp. 48, 120, 135; National Oceanic and Atmospheric Administration (NOAA): pp. 72 (Steve Nicklas, NOS, NGS), 166 (Rear Admiral Harley D. Nygren, NOAA Corps, ret.); H. Pellikka: p. 157; Kevin Poh: pp. 28–9; Quistnix: p. 132; ReVolt House team, TU Delft: p. 141; Rex Features: pp. 53 (Sipa Press), 145, 147 (KeystoneUSA-ZUMA), 148–9 (Sipa Press), 168 (Jeff Blackler); Richerman: p. 31; McKay Savage: p. 172; Pierre Selim: p. 61; U.S. Department of Defense: pp. 43 (PFC Nicholas T. Howes, USMC), 146 (Horace Murray, U.S. Army); U.S. Department of the Interior/Bureau of Reclamation: p. 123; U.S. Marine Corps: pp. 49 (Sgt Ezekiel R. Kitandwe), 152 (Cpl Robert J. Maurer); U.S. Navy: p. 167 (Photographer's Mate 1st Class Alan D. Monyelle); U.S. Navy National Museum of Naval Aviation: p. 130 (Cdr John C. Redfield, USCGR, ret.); Vmenkov: p. 37; Vincent de Vries: p. 138; Harald Weber: p. 151; Werner Forman Archive: p. 127; Wikifrits: p. 58; zaefra: p. 30; Chen Zhao: p. 160.

INDEX